Is photography permitted?

Non-flash photography of our permanent collection is encouraged. On select days and in certain special exhibitions, photography isn't allowed. Just look for the "no-photography" symbol.

Can I bring pencils and art supplies into the galleries?

Pencils and paper are allowed. Please go to the Visitor Services desk to sign a Sketching Policy before beginning your drawing. Other art materials including paint and ink are not permitted except during staff-led programs.

How do I find out about Museum events?

Visit the Museum's website www.SDMArt.org to find the most up-to-date information on exciting happenings at the Museum and learn how you can be a part of them!

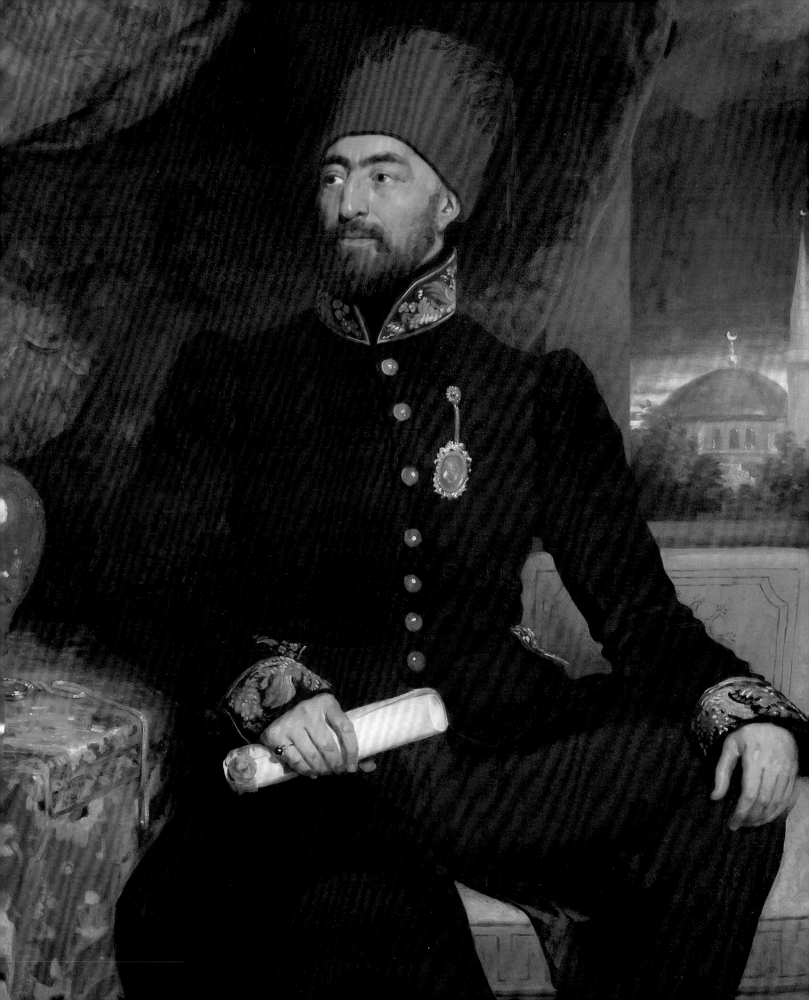

Art Unframed

at The San Diego Museum of Art

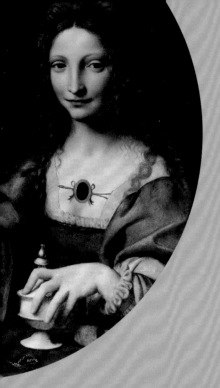

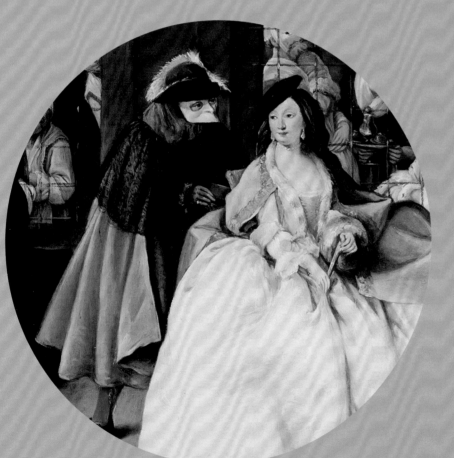
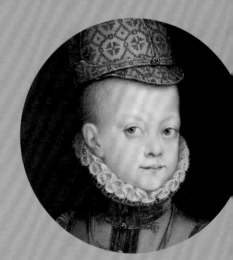

Myths, Angels, and Masquerades

Exploring European Art

Amy Gray and Lucy Holland

THE SAN DIEGO MUSEUM OF ART

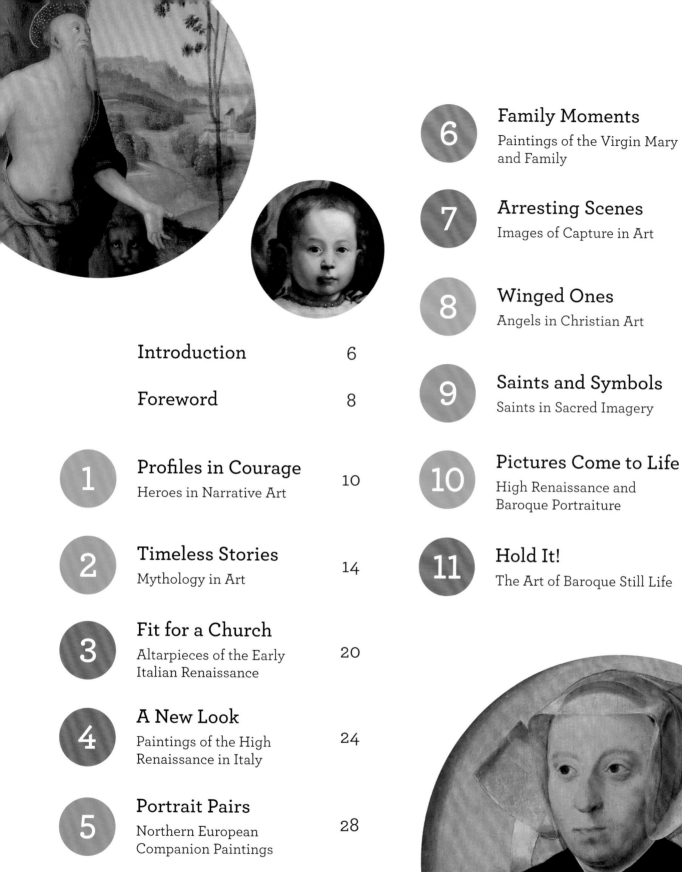

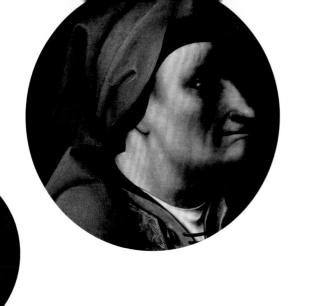

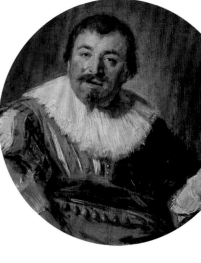

Introduction

The publication of *Myths, Angels, and Masquerades: Exploring European Art* is a source of great pride for The San Diego Museum of Art, and the Department of Education and Public Engagement in particular. An integral part of our mission is to provide families with tools for interpreting, understanding, and enjoying the art in our collection. It's what we strive to do in all our work. Not only does this publication do exactly that, it marks the first book created by the Museum's Department of Education and heralds the beginning of a new series of books, Art Unframed, which will guide children and families toward a deeper understanding of different aspects of the Museum's Permanent Collection.

To inaugurate the series, we have chosen to explore the fascinating world of European art through the Museum's extensive and significant European collection. In this book, you'll find forty-seven works of European art that highlight several important themes, including religion, landscapes, the emergence of still-life painting, and the evolution of portraiture.

Throughout the book, interactive features provide opportunities for further investigation and contemplation, while the "Your Turn" feature invites readers to try their own hands at creating art inspired by the book's themes. Art terms in bold are defined in the glossary at the back of the book. Stickers and cut-outs, such as a masquerade mask that can be decorated and worn, provide a tactile element that truly brings the art to life for children.

Authors Amy Gray and Lucy Holland, art educators at The San Diego Museum of Art, committed countless hours to researching, writing, and developing the educational activities within the book. Their goal was to craft a rich, interactive encounter with art for the whole family. The result shows that they have excelled at this endeavor. The support of Roxana Velásquez, Katy McDonald, and Rebecca Dickinson Welch was instrumental in bringing the book's publication to fruition.

The collection of The San Diego Museum of Art contains many treasures. Now, with the Art Unframed series beginning with *Myths, Angels, and Masquerades*, readers and visitors will have an opportunity to see these works of art in a new way, transforming and deepening their appreciation for art. Welcome to this journey through the European collection at The San Diego Museum of Art. We put it together thinking of you.

Sandra Benito

Deputy Director for Education
and Public Engagement
The San Diego Museum of Art

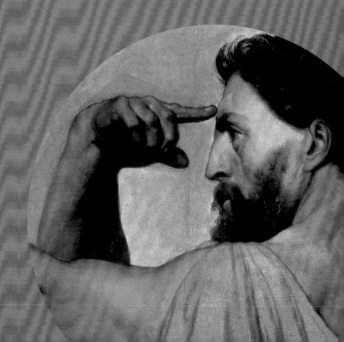

Foreword

At The San Diego Museum of Art, we have the great privilege of caring for some of the world's finest art. In addition to preserving and studying the over 17,000 works of art in our Permanent Collection, sharing this art with the public is at the heart of the Museum's mission.

Upon the occasion of the Museum's ninetieth anniversary, we are delighted to share one important area of our collection through the publication of this book, especially created with young art enthusiasts in mind. An in-depth yet accessible look at the Museum's collection of European art spanning nearly five hundred years, *Myths, Angels, and Masquerades: Exploring European Art* provides young readers with a window into the traditions of European art, introducing key themes, techniques, subject matter, and symbols in an engaging and creative way.

This publication would not have been possible without the generous contribution provided by the Donald C. and Elizabeth M. Dickinson Foundation and Rebecca Dickinson Welch in honor of Alek Crissy Dickinson and Connor Michael Dickinson. Additional support was provided by the County of San Diego Community Enhancement Program, the City of San Diego Commission for Arts and Culture, and the members of The San Diego Museum of Art. This support was vital to the success of the project.

Much credit for the vision of this book goes to Sandra Benito, Deputy Director for Education and Public Engagement, whose innovative leadership has expanded our educational reach and ensured that the Museum is a welcoming destination for all curious minds. Gratitude is due, as well, to her team of experienced art educators, including book authors Amy Gray

and Lucy Holland. The publication of this book, and with it the launch of the Art Unframed book series, represents the next important step for the Department of Education, as art from the Museum's collection can now be shared with an even broader audience and treasured by families for decades to come. I want to express my gratitude to Dr. John Marciari, who provided research materials from his catalogue, *Italian, Spanish, and French Paintings before 1850 at The San Diego Museum of Art*, as well as to Patrick Coleman, editor of the book.

As The San Diego Museum of Art celebrates ninety years of sharing the world's finest art in San Diego and around the world, it is appropriate that we now present to you this educational exploration of some of the highlights of our European collection. We hope you will find enjoyment as much as enlightenment on the journey within these pages.

Roxana Velásquez

Maruja Baldwin Executive Director
The San Diego Museum of Art

Profiles in Courage
Heroes in Narrative Art

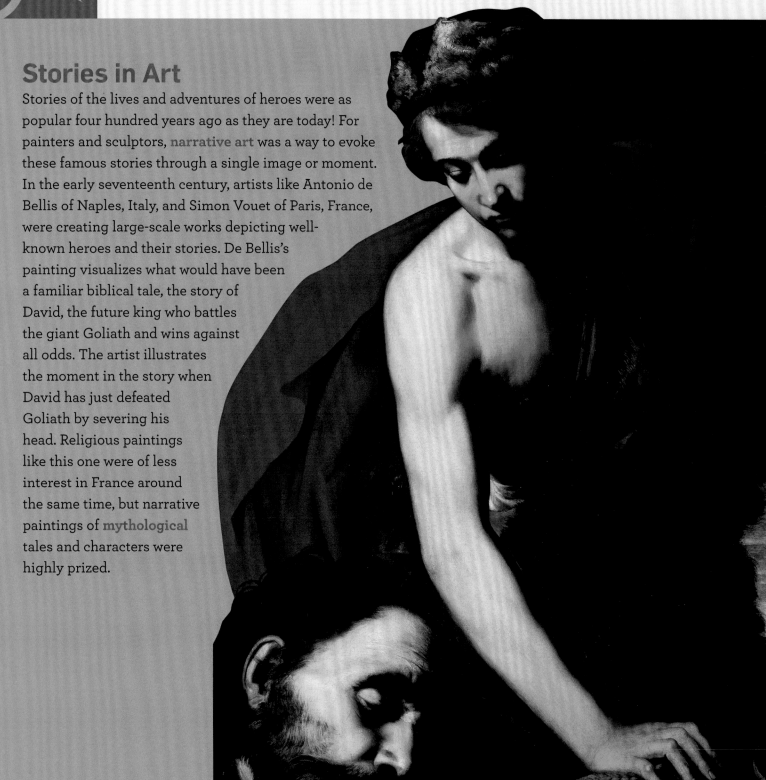

Stories in Art

Stories of the lives and adventures of heroes were as popular four hundred years ago as they are today! For painters and sculptors, **narrative art** was a way to evoke these famous stories through a single image or moment. In the early seventeenth century, artists like Antonio de Bellis of Naples, Italy, and Simon Vouet of Paris, France, were creating large-scale works depicting well-known heroes and their stories. De Bellis's painting visualizes what would have been a familiar biblical tale, the story of David, the future king who battles the giant Goliath and wins against all odds. The artist illustrates the moment in the story when David has just defeated Goliath by severing his head. Religious paintings like this one were of less interest in France around the same time, but narrative paintings of **mythological** tales and characters were highly prized.

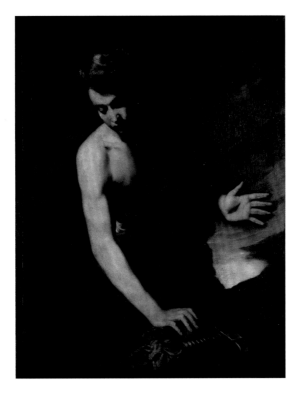

David with the Head of Goliath, before and after conservation.

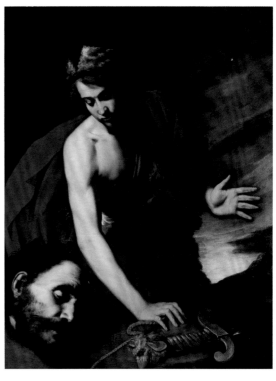

Antonio de Bellis (ca. 1616–ca. 1660). *David with the Head of Goliath*, ca. 1640. Oil on canvas.

What's Under There?

There are mysteries and surprises hiding within—sometimes even under—works of art. This work was once known as *David with the Sword of Goliath* because before 1986 you wouldn't have seen Goliath's head in the painting. An x-ray confirmed that the head of Goliath had been painted over by a later hand, most likely to make the work more appealing to a wider audience. More than ten years after this discovery, a conservator was hired to remove the overpaint to reveal the hidden head of Goliath.

Did You Know?

Naples was the second largest city in Europe after Paris during the seventeenth century. In 1630, it was a center of opportunity for artistic commissions, or works of art that an artist is hired to create specifically for a patron.

NAPLES

11

The Whole Story

Narrative art may attempt to capture the entire tale or show us just one moment from it. For example, the story of Aeneas fleeing Troy is just one scene from Virgil's *Aeneid*, an epic poem about events following the Trojan War. Here we see the part of the story when Aeneas's wife has picked up the statues of the family's household gods, and Aeneas is lifting his father onto his back to carry him out of the burning city. When Aeneas is just outside the city, he realizes that his wife is no longer with him, and he flies back to Troy to find her. Soon, her ghost appears to him to let him know she has passed away but that he should go to Italy to marry a new woman—a queen.

Simon Vouet (1590–1649). *Aeneas and His Family Fleeing Troy*, ca. 1635–40. Oil on canvas.

Creative Eye Movement

In this painting, the artist helps us to travel through the complex composition more easily by using directional lines to guide our eyes. Look for a strong diagonal line created by the top of each figure's head, extending from the upper right corner to the center of the left side. At the same time, Aeneas's right arm and his father's left arm create a circle which leads up to their heads and directs our attention to their embrace, the focal point of the painting and the story.

Echoes of the Past

Vouet was one of the most important artists in Paris during the early seventeenth century. Although he was French and became the main court painter for King Louis XIII, his work is influenced by some of the greatest masters of Italian art. His love of classical themes relating to ancient Greece and Rome echoes the works of Renaissance masters like Raphael and Michelangelo. He used a more naturalistic style to depict objects and people accurately and with attention to detail. The use of more natural light in his work suggests the influence of Venetian artists, such as Paolo Veronese (see page 15), who was seen as an expert in creating soft, warm light in paintings during the sixteenth century.

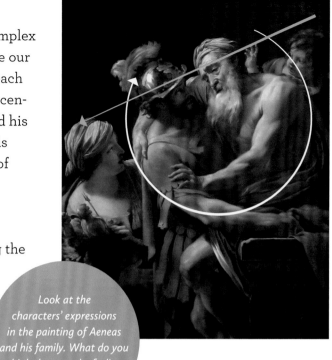

Look at the characters' expressions in the painting of Aeneas and his family. What do you think they may be feeling in this moment?

Can You Find

The statues of household gods wrapped in fur for safe travel.

Your Turn

Heroic Moment Story Board

Think of a time when you or someone you know had to be brave, and tell the story of what happened using pictures. Fold a long strip of paper in half twice to create four similarly sized boxes. Then, divide the story into four different moments and illustrate them in the boxes in the order that they happened.

Timeless Stories
Mythology in Art

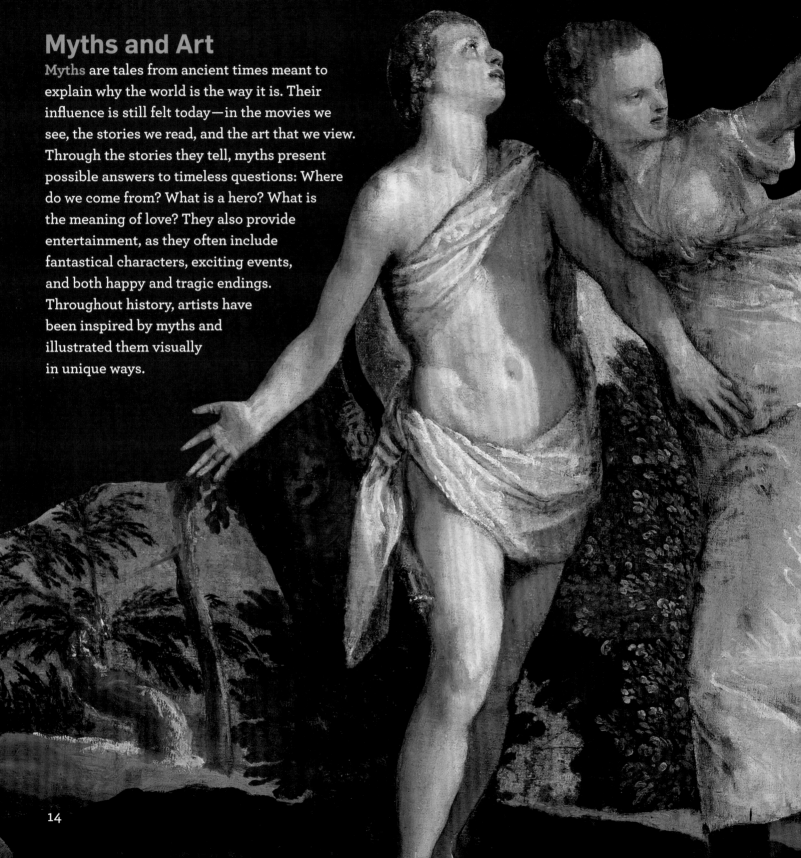

Myths and Art

Myths are tales from ancient times meant to explain why the world is the way it is. Their influence is still felt today—in the movies we see, the stories we read, and the art that we view. Through the stories they tell, myths present possible answers to timeless questions: Where do we come from? What is a hero? What is the meaning of love? They also provide entertainment, as they often include fantastical characters, exciting events, and both happy and tragic endings. Throughout history, artists have been inspired by myths and illustrated them visually in unique ways.

An Endless Love

In Greco-Roman mythology Daphne was a youthful and beautiful nymph who became the love interest of Apollo, god of the sun, after he was shot by Cupid's gold-tipped, love-inducing arrow. Daphne was hit by Cupid's lead-tipped, love-repelling arrow instead and ran away from Apollo, who gave chase. She pleaded for help and was transformed into a laurel tree by her father's powerful enchantment. Apollo was heartbroken, but he gently picked a branch from the tree and shaped it into a crown to wear, forever connecting him to Daphne. Apollo also adopted the laurel as a symbol of the arts, especially poetry. To this day, a poet appointed by a government or other organization is called a "poet laureate," which means a "laurel crowned poet."

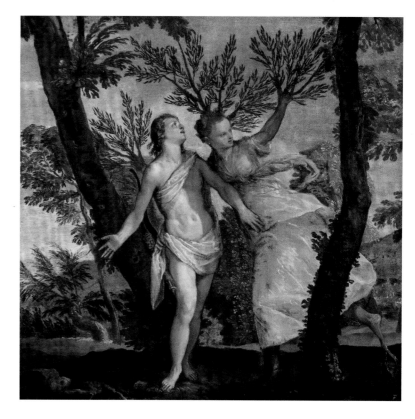

Paolo Caliari, called Veronese (1528–1588). *Apollo and Daphne*, ca. 1560–65. Oil on canvas.

The Rewrite

When myths are retold through works of art, the artist has an opportunity to reinvent the tale. Creative choices on which particular moments and details from the story to include or leave out often reflect the values of the artist's time. Italian artist Paolo Caliari, better known as Veronese, did numerous narrative paintings of mythological figures throughout his career. Many artists before him had created representations of the myth of Apollo and Daphne in both painting and sculpture, usually depicting the scene from the story when Apollo is chasing Daphne. Veronese's painting, however, shows a later moment in the story, when Apollo has caught up with Daphne as she becomes a tree, placing more emphasis on Apollo's reaction to the transformation.

If you were the artist, which moment would you choose to share from the story?

Color Change

Believe it or not, color is a very important part of Veronese's work, as we can see in his painting at left. He was known as a supreme colorist and used large pools of bright hues in his work. That rich color is hard to detect in *Apollo and Daphne* because it was built up in a series of layers that were almost entirely removed in harsh cleanings long ago. Much of what we see is just the underpainting and other ground layers of the piece.

Paolo Caliari, called Veronese (1528–1588). *The Choice Between Virtue and Vice*. ca. 1565. Oil on canvas. 1912.1.129. The Frick Collection, New York.

Did You Know?

Apollo and Daphne and a number of Veronese's other paintings from the 1560s were drawn from stories found in Ovid's *Metamorphoses*, a semi-mythical narrative poem written in ancient Rome about the early history of the world.

Your Turn

Decorative Laurel Crown

Laurel crowns were given to scholars, poets, and conquering heroes in ancient Greece, and are still given to some university graduates. Create your own laurel crown using materials of your choice. Then, have a poetry contest with your friends and family and crown the winner!

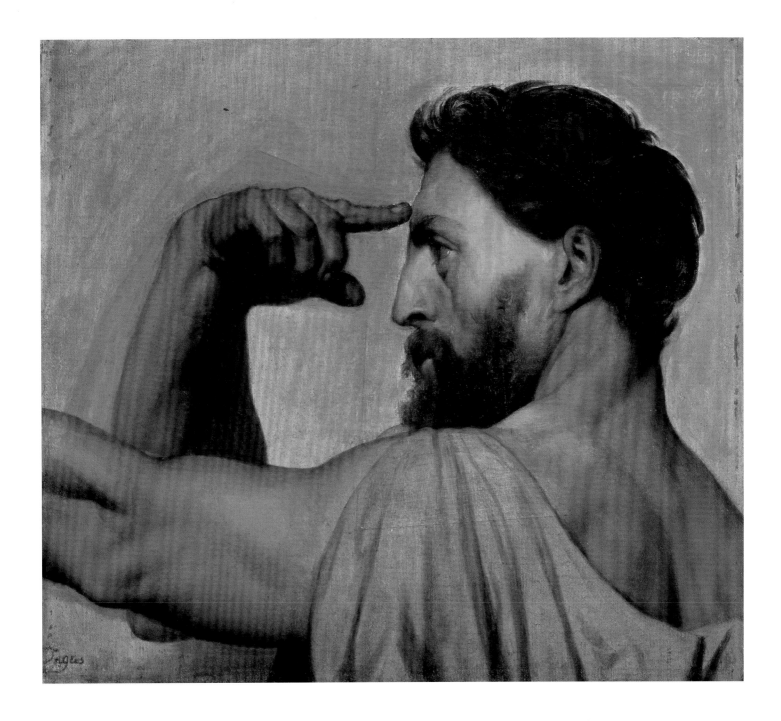

Study, Study, Study

This painting, created by nineteenth-century French artist Jean-Auguste-Dominique Ingres and once owned by Edgar Degas (see page 86), is a study for the larger painting called *The Apotheosis of Homer*. A "study" is the term used for a practice piece, a quick painting that captures the essence of a subject or scene and is meant to test a composition rather than serve as a final work of art. A study is more refined or finished than a sketch and can include everything that will be in the final painting or just small sections of it. This painting is one of over two hundred studies—both paintings and drawings—that the artist created in preparation for the larger work.

Jean-Auguste-Dominique Ingres (1780–1867). *Study for Phidias in "The Apotheosis of Homer,"* ca. 1827. Oil on canvas, laid down on panel.

17

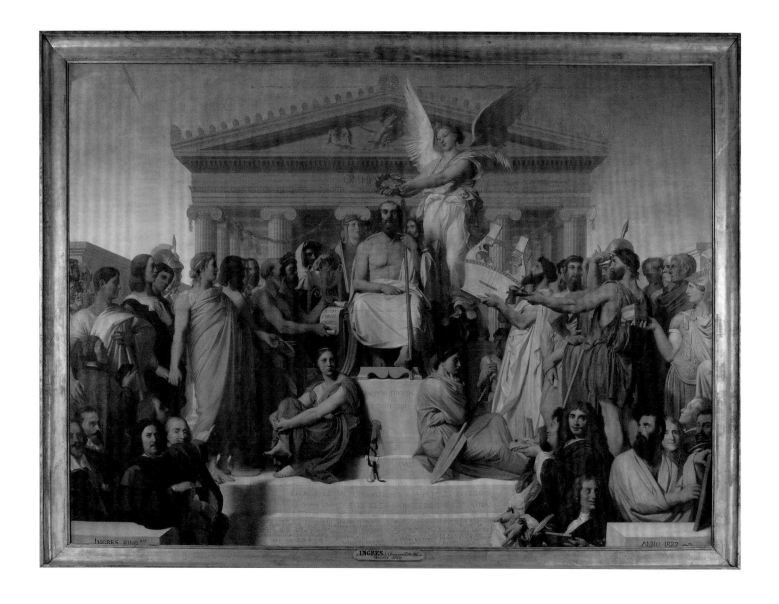

Jean-Auguste-Dominque Ingres (1780–1867). *Homer Deified, or The Apotheosis of Homer*, 1827. Oil on canvas. Musée du Louvre, Paris. Alinari/Art Resource, NY.

A Nod to the Past

The *Iliad* and the *Odyssey* are well-known ancient Greek epics, written in the eighth century BC by the poet Homer. These three-thousand-year-old epics are some of the earliest works of Western literature and have had enormous influence on literature, art, and culture through the ages. They are also the foundation for much of the history and mythology of the ancient world as we know it today. Ingres paid tribute to the author of these epics when he exhibited his seventeen-foot-long painting *The Apotheosis of Homer* in 1827. In this work, the revered poet is seated in the middle of the composition, surrounded by forty-six different ancient and modern artists and thinkers, each offering him a gift.

Can You Find

Phidias in the crowd.

Ancient Influence

Ingres was interested in celebrating the contributions of ancient Greece and Rome through the art that he made. He was a student and key representative of Neoclassicism, an artistic style that began in the eighteenth century that drew inspiration from ancient Greek and Roman art and culture. Like other Neoclassicists of his time, Ingres's style includes an emphasis on solid forms and monumental scenes. Many of his subjects are classical or historical themes, and he painted his figures in a very sculptural style, as if carving a Greek statue.

Did You Know

Phidias was a Greek artist commonly regarded as one of the greatest sculptors of ancient Greece. In the larger work for which this study was made, Phidias holds a mallet and chisel in his extended hand.

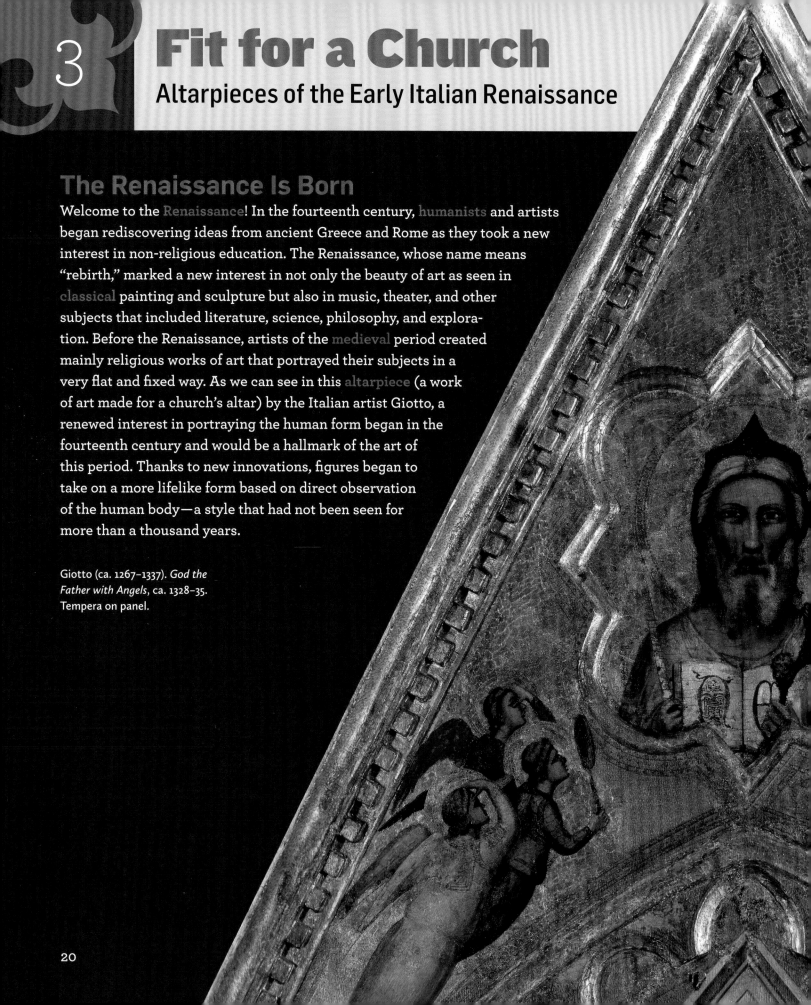

Fit for a Church

Altarpieces of the Early Italian Renaissance

The Renaissance Is Born

Welcome to the Renaissance! In the fourteenth century, humanists and artists began rediscovering ideas from ancient Greece and Rome as they took a new interest in non-religious education. The Renaissance, whose name means "rebirth," marked a new interest in not only the beauty of art as seen in classical painting and sculpture but also in music, theater, and other subjects that included literature, science, philosophy, and exploration. Before the Renaissance, artists of the medieval period created mainly religious works of art that portrayed their subjects in a very flat and fixed way. As we can see in this altarpiece (a work of art made for a church's altar) by the Italian artist Giotto, a renewed interest in portraying the human form began in the fourteenth century and would be a hallmark of the art of this period. Thanks to new innovations, figures began to take on a more lifelike form based on direct observation of the human body—a style that had not been seen for more than a thousand years.

Giotto (ca. 1267–1337). *God the Father with Angels*, ca. 1328–35. Tempera on panel.

Follow the Leader

As the "Father of the Renaissance," Giotto was considered the first to revive classical traditions in the fourteenth century. Master artists like Giotto had numerous assistants, often students or **apprentices,** who handled the more mundane tasks for the **workshop**, such as grinding **pigments** and preparing materials. Once the apprentice had learned the ropes, he would be made a **journeyman** and help the master artist with more important duties. Often apprentices and journeymen, as they practiced their skills, would copy the master artist's work or attempt to imitate his style in their own works of art—sometimes even signing the master's name. This was one of the ways the innovative style of early Renaissance painting spread but would lead to confusion centuries later. **Curators** sometimes discover that a work of art once previously thought to be by a master artist was instead created by someone— often anonymous— in the workshop of that artist.

Did You Know?

A master artist was responsible for the overall design and would paint the most important works. For less important paintings, the master would possibly handle only the most difficult features of the painting—the faces and hands—or even leave all of the painting to assistants. Though Giotto definitely designed this work, there is ongoing debate about whether it was painted by the master himself or by Taddeo Gaddi, his primary assistant.

A Bright Prospect

Notice how the angels in this altarpiece fragment are flying up toward the figure of God in the center, but they must shield their eyes from the bright light that radiates from Him. Some close their eyes while others hold dark glasses in front of their faces.

Here Comes Saint Nick

Saint Nicholas of Bari—a.k.a. Santa Claus—is represented here by the artist Giovanni Bonsi. We know that this must be a representation of Saint Nicholas because he is shown with specific **attributes** that identify him. For example, he is dressed in the robes of a bishop, which is commonly how he was pictured, and holds three golden balls that stand for the gifts he offered to a man who was in need of dowry for his daughters. Hence, the spirit of giving at Christmas is evoked. Stories and how they are shown visually change over time. How is this portrayal of Saint Nicholas different than the popular representations of him today?

Can You Find

A mouse.

As Good as Gold

Gold is very important in Renaissance paintings because it signifies the heavens. Often altarpieces are finished in **gold leaf**, which was made from real gold. A gold coin would have been hammered until it was less than paper thin and then delicately applied to the surface of a panel over a kind of clay called **bole** that makes it stick. After it was applied, the gold would have been polished with a tool to make it shiny and smooth. Both real and artificial gold leaf are still used in art today.

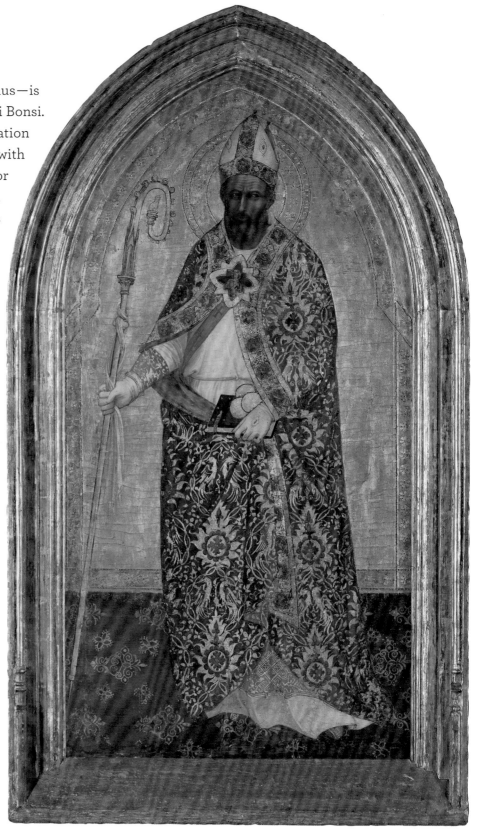

Giovanni Bonsi (active by ca. 1350; died 1375/76). *Saint Nicholas of Bari*, ca. 1365–70. Tempera on panel.

The Blue of the Gods

Artists in the Renaissance worked with materials that they sourced from the earth. This included pigments ground from rocks, minerals, or plants that were mixed with egg as a binder to create durable **tempera paint**. The most exquisite of these colors was a brilliant blue that was ground from lapis lazuli, a semi-precious stone found in central Asia, in what is now Afghanistan. This was the most expensive pigment to purchase—even more expensive than gold!—since it had to be shipped for many miles via camel and boat from Asia along the Silk Road to reach Europe. Because of its rarity, the color was reserved for the most important figures in a work of art—often the Virgin Mary.

Did You Know?

As works of art were detached and sold over the years, many altarpiece fragments wound up separated from the other parts to which they were originally joined. The panel painting of Saint Nicholas is just the right-hand part of a three-panel altarpiece, or a **triptych**. Likewise, the Giotto work is only a small fragment—the very top of the original—while the rest of this altarpiece, which depicts the coronation or crowning of Mary, still resides in its original location at the Church of Santa Croce in Florence.

Giotto (ca. 1267–1337). *Baroncelli Altarpiece*, ca. 1327–34. Tempera on panel. Florence, Church of Santa Croce. Alinari/Art Resource, NY.

Your Turn
Create a Personal Altarpiece

Create your own personal altarpiece that expresses something about yourself and your interests. Using the altarpiece provided, decorate the panel using collage. Cut out images from magazines that appeal to you and glue them to the altarpiece. You can decorate the background with motifs or patterns, but leave some of the gold showing through. When you are finished, place your altarpiece in your room as a personal altar.

A New Look
Paintings of the High Renaissance in Italy

In with the New!

The depiction of figures evolved during the **High Renaissance**, the height of artistic achievement in the early sixteenth century. Artists demonstrated even more mastery of human form, pose, and expression. Large advances were made in the study of anatomy and **proportion**, alongside other new discoveries in science and astronomy during this unique period of history. Italian painters Bernardino Luini and Vincenzo Catena worked during this time of great innovation in art and science. If we compare the way figures are painted in Catena's *Holy Family with Saint Anne* and Luini's *Conversion of the Magdalene* (at right and below) to earlier Renaissance paintings, such as those by Giotto or Bonsi (see pages 20–22), we can notice several striking differences. The soft, blended brushwork and the **realistic** portrayal of the figures of the paintings seen here are characteristic of the High Renaissance, while the earlier works appear flatter and less dynamic.

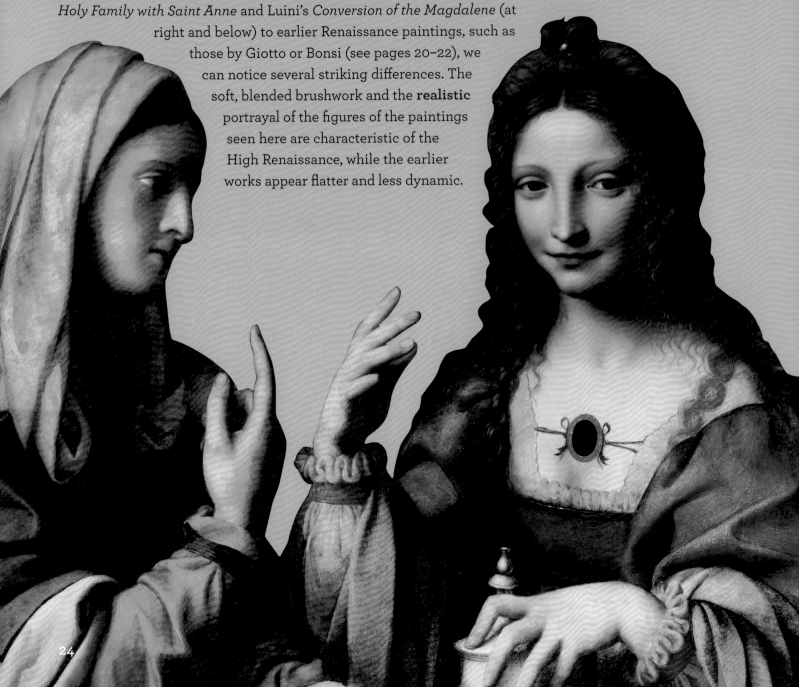

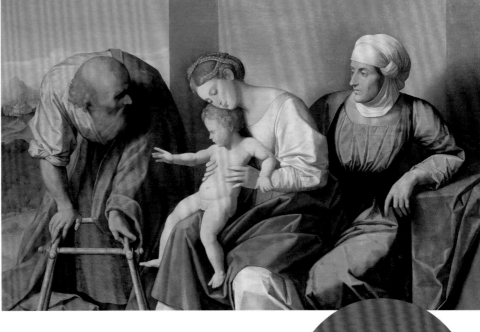

Vincenzo Catena (ca. 1475–1531). *Holy Family with Saint Anne*, ca. 1510–15. Oil on panel.

A Day in the Life of the Holy Family

Catena, a well-known painter of the High Renaissance, was unlike most other artists from the time in that he was already very wealthy and highly educated when he decided to become a painter. He worked in a traditional style that he learned from Giovanni Bellini, a famous Venetian Renaissance artist, and frequently represented biblical imagery in his works. This painting shows us an intimate moment in the life of the Holy Family—baby Jesus with his mother (Mary), father (Joseph), and grandmother (Anne). The wooden walker that Joseph leans on isn't for him—it's a baby walker

that he likely made in his carpenter's woodshop. Mary and Joseph bend tenderly toward Jesus, whom they may be teaching how to walk.

Comparing the Catena painting to an early Renaissance altarpiece by Giotto or Bonsi, what other differences do you notice about the way the figures are painted?

Did You Know?

Catena shared an art studio between about 1504 and 1510 with Giorgione, another—and more famous—Renaissance painter (see page 52). However, Catena was the more well-established artist at the time. The two artists worked closely together, and even shared their materials. An x-ray of a Giorgione painting (one of his **self-portraits**) revealed that he painted right over one of Catena's works!

Can You Find?

A castle.

Glamor or Glory?

This High Renaissance painting by Luini reveals a biblical story of two very different sisters. Mary Magdalene, the woman on the right, enjoyed having fine possessions and is shown with her fancy jewelry, expensive clothing, ointment jar, and a letter on the table before her. Her saintly sister Martha (on left), on the other hand, focused more on the spiritual realm than the material world. This painting illustrates the moment that Mary converts to Christianity. In convincing Mary to give up her obsession with material objects, Martha points upward to heaven. One of the painting's titles, *An Allegory of Modesty and Vanity*, suggests the virtues and vices the two different women represent through **allegory**, in which characters or events represent hidden meanings or ideas.

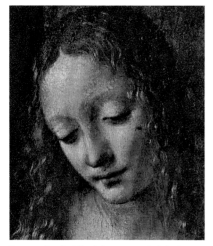

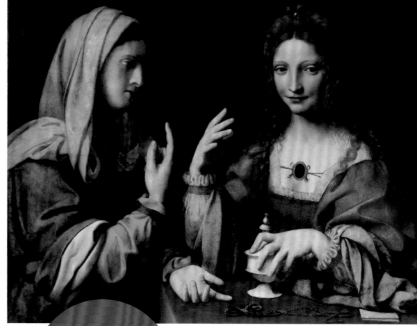

Imagine the dialogue that took place between these two sisters. What do you think they would have said to each other?

Bernardino Luini (1481/82–1532). *The Conversion of the Magdalene (An Allegory of Modesty and Vanity)*, ca. 1520. Oil on panel.

Did You Know?

Though we are more used to seeing images of a youthful Mary Magdalene, as she is shown here, she was often represented as an older, less glamorous woman.

Leonardo da Vinci (1452–1519). *Virgin of the Rocks* (detail), 1483–86. Oil on panel. Musée du Louvre, Paris, France/Bridgeman.

A Leonardo Copycat

Luini was thought of as a forward-thinking artist of the High Renaissance, and was influenced in developing his style by the famous Leonardo da Vinci, considered a master in his own day (as he is today). Luini painted his version of Mary Magdalene with a mysterious smirk, soft gaze, and golden curls in a way that mimics Leonardo's style and techniques seen in the painting to the left, allowing us to say that this representation looks very "Leonardesque." Luini admired Leonardo's work, and both artists worked in northern Italy, so it is no surprise that he, along with Giorgione and several other painters, would have copied his techniques.

Your Turn

Be the Copycat

Find a work of art that inspires you with its style, subject matter, or color. Take a turn being the copycat—great artists learn by imitating other artists' work and have been doing so for centuries. Study the painting closely and then copy it (or parts of it) in the frame below.

Portrait Pairs
Northern European Companion Paintings

He Loves Me ...

Skilled artists have been commissioned to paint portraits of wealthy aristocrats, merchants, scholars, clergy, and often royalty across centuries of European art. Some portraits would capture the exact likeness of a sitter while others would glamorize the person, smoothing out flaws in her or his features. Sometimes portraits were created for a specific purpose or event, which tells us about the sitter's status and culture. These northern European Renaissance paintings contain clues that provide insight into who the people were, where they lived, and what occasion they were celebrating. Comparing the man at right to the woman on the next page, notice the carnation that each holds. This is an important detail, which tells us that the man and woman each were engaged to be married. The portraits of their soon-to-be spouses, presented on separate panels that once accompanied each of these portraits, are not by their sides anymore— scattered to different museums around the world.

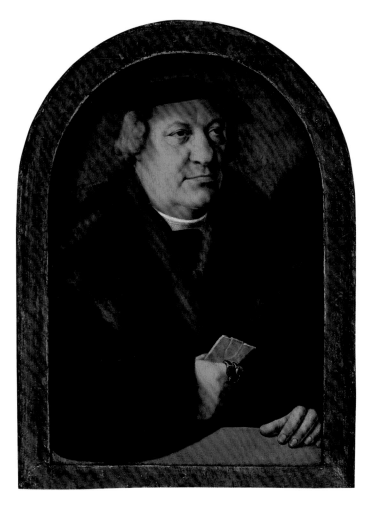

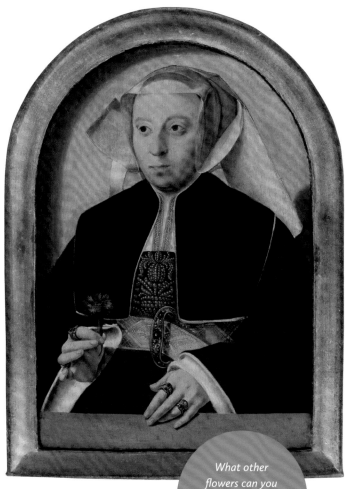

What other flowers can you find in paintings from the Renaissance or Baroque eras?

My Better Half

Marriage in the Renaissance was often arranged by families, sometimes for financial reasons. Painters in northern Europe such as Bruyn the Elder and Breu the Elder were commissioned to paint **diptychs** (two-panel paintings) commemorating the engagement of couples. The bride-to-be would accompany her fiancé in these dual portraits, which would have been hinged together so the couple faced toward each other.

Did You Know?

Flowers are important visual symbols in Renaissance art. A red carnation is a symbol of true love and indicates an engagement for marriage. On the wedding day, often the bride would carry a carnation.

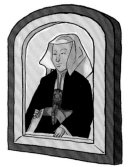

ABOVE LEFT
Barthel Bruyn the Elder (1493–1555). *Portrait of Scholar Petrus von Clapis*, 1528. Oil on panel. Museum of Fine Arts, Budapest.

ABOVE RIGHT
Barthel Bruyn the Elder (1493–1555). *Lady with Carnation*, ca. 1525–30. Oil on panel.

A Bright Future

Each sitter is dressed in a style that was common to fifteenth-century Germany. The woman on the previous page wears a white cap and full dress, since modesty was valued in potential brides. But check out her fine jewelry and ornate belt buckle, which indicate her nobility nonetheless.

The young man is also situated to impress his new fiancée. He is shown against a vast landscape, perhaps indicating that he is lord of a large amount of land.

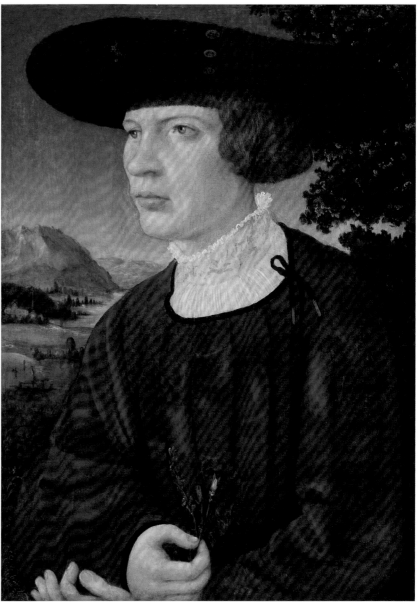

Jörg Breu (ca. 1475–1537). *Portrait of a Young Man*, ca. 1510. Oil on panel.

If you were having your portrait painted, against what kind of background would you choose to pose?

Can You Find?

A ship.

Painting with Oils

Bruyn the Elder and Breu the Elder, both German artists, were influenced by paintings from Italy where the Renaissance began. The Renaissance, which lasted roughly two centuries, had only reached Germany and northern Europe once it was well underway. Unlike many Italian artists at the time, these German painters used oil paint, which was a medium invented in northern Europe. Instead of using egg yolk as a binder, pigments were mixed with walnut, linseed, or poppyseed oil to achieve deep, bold colors that were often richer than those achieved with tempera paint. Artists often preferred slow-drying oil paints because they allowed the painter to gradually change colors and details in a painting as they reworked sections that otherwise would have dried with tempera, a fast-drying medium.

Your Turn
Draw the Bride

This young man's companion piece doesn't hang next to him today. Reunite the happy couple by imagining what his fiancée would have looked like and drawing her in the space provided.

Family Moments

Paintings of the Virgin Mary and Family

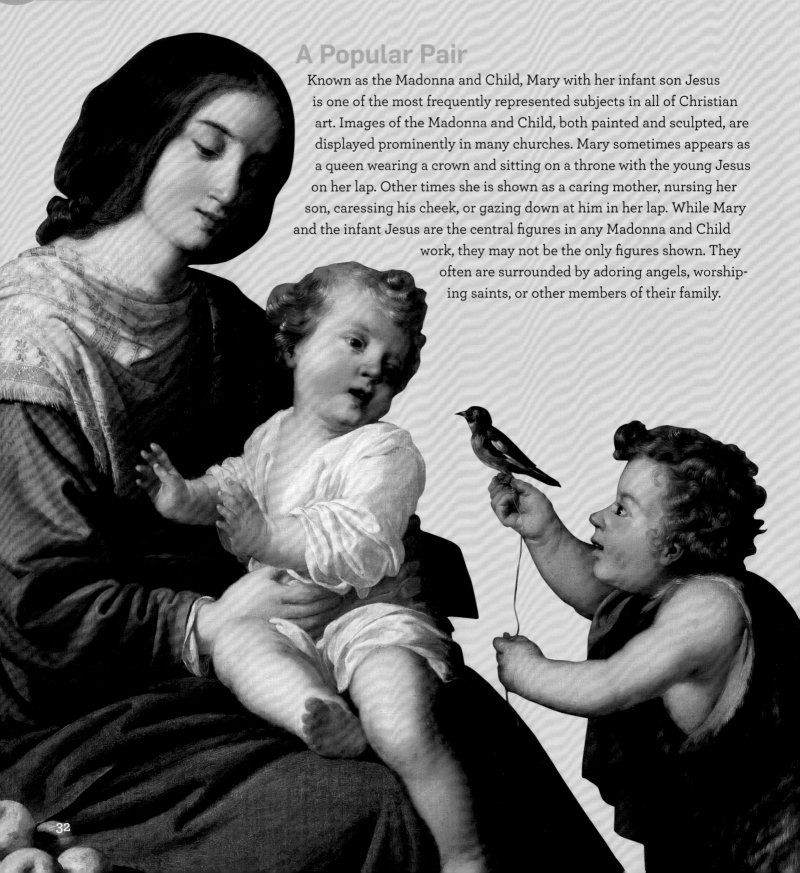

A Popular Pair

Known as the Madonna and Child, Mary with her infant son Jesus is one of the most frequently represented subjects in all of Christian art. Images of the Madonna and Child, both painted and sculpted, are displayed prominently in many churches. Mary sometimes appears as a queen wearing a crown and sitting on a throne with the young Jesus on her lap. Other times she is shown as a caring mother, nursing her son, caressing his cheek, or gazing down at him in her lap. While Mary and the infant Jesus are the central figures in any Madonna and Child work, they may not be the only figures shown. They often are surrounded by adoring angels, worshiping saints, or other members of their family.

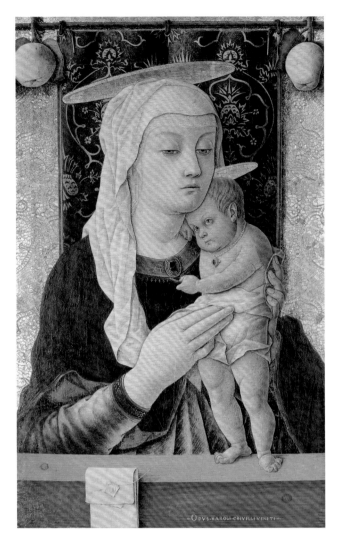

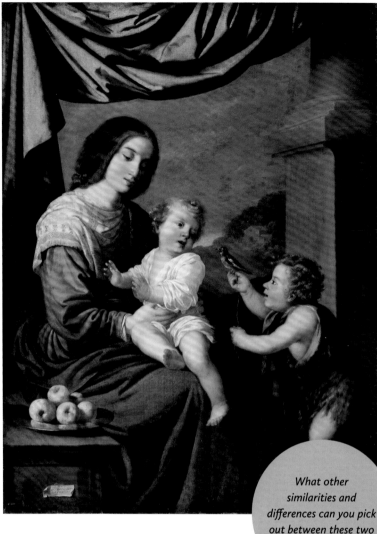

What other similarities and differences can you pick out between these two works?

ABOVE LEFT
Carlo Crivelli (ca. 1430/35–1495). *Madonna and Child*, ca. 1468. Tempera and oil on panel.

ABOVE RIGHT
Francisco de Zurbarán (1598–1664). *Virgin and Child with the Young Saint John the Baptist*, 1658. Oil on canvas.

Can You Find?

The pomegranate design in the curtain.

What's the Same? What's Different?

When comparing works featuring the Virgin Mary, Jesus, and family created at different times and places, we can see revealing similarities and differences between them. Although created two hundred years apart and in different countries, the *Madonna and Child* (1468) by Italian artist Carlo Crivelli and *Virgin and Child with the Young Saint John the Baptist* (1658) by Spanish painter Francisco de Zurbarán are painted with great naturalism. Both of these images are so naturalistic, in fact, that you may even be fooled into thinking you're looking at real objects instead of painted ones. But there are also big differences in style between these paintings. The figures in Zurbarán's express movement and emotion—a stark contrast to the stillness of the Crivelli *Madonna and Child*—and the lighting, coloring, and even the props in the background, such as the posts and curtains, suggest a more theatrical setting.

Spanish Masters

Along with Zurbarán, Juan de Valdés Leal was one of the most popular Spanish painters in the Baroque style of the seventeenth and early eighteenth centuries. Note the dramatic, stage-like setting and strong contrast of lights and darks that were typical of this style. Valdés Leal was known for his dynamic brushwork and his emphasis on theatricality, much like Zurbarán. This painting captures the Virgin Mary and family interacting in an unusual moment. Mary, on the left, is pregnant with Jesus, and her cousin Elizabeth is pregnant with Saint John the Baptist. Their husbands, Joseph and Zacharias, greet each other in the background. The two women lean in toward one another. Though you can't see it, the story relates that as John senses the presence of Jesus from within the womb, he dramatically leaps for joy. Notice how Valdés Leal, using different techniques, shares Crivelli and Zurbarán's knack for depicting objects naturalistically.

How is emotion expressed in the faces of these two women? What do you imagine they are feeling?

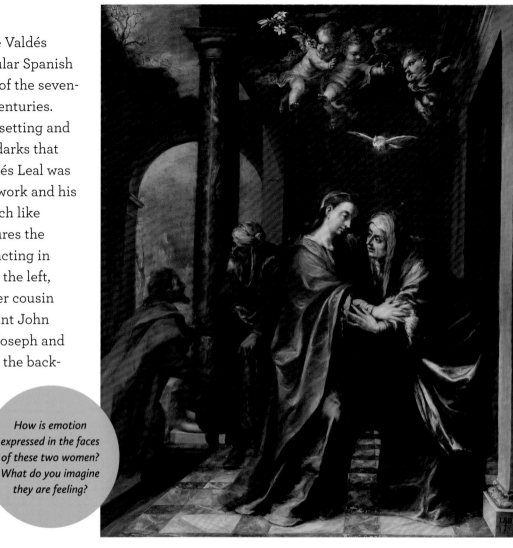

Juan de Valdés Leal (1622–1690). *The Visitation*, 1673. Oil on canvas.

Did You Know?

Valdés Leal's son, who would have been a teenager when *The Visitation* was painted, helped his father in his workshop and learned how to paint from him. Like father, like son! It is thought that he helped paint parts of this particular work—the background, most likely.

Searching for Symbols

When looking closely at these paintings, we can find many symbols, or objects that stand for something other than themselves, often ideas. Artists use clothing, animals, and even fruits and vegetables to help us identify individuals and ideas. In the Zurbarán work, the young boy who holds out a small bird to the infant Jesus wears a fur covering. This symbol helps us identify him as Saint John the Baptist, clothed in this way because he would later spend much time preaching in the wilderness. In the painting by Valdés Leal, the dove and the three white lilies are symbols meant to represent purity and the Holy Spirit, a way to indicate the presence of Jesus in Mary's womb. You may also have already noticed that in all three of these paintings Mary is wearing blue. The color is most often associated with Mary and has important symbolic meaning in Christian art, standing for truth and clarity. Fruit is often more than just a snack in the world of Christian art. The apples in the paintings by Crivelli and Zurbarán symbolize the idea of original sin as explained in the biblical story of Adam and Eve, the first man and woman, who were expelled from Eden after eating the forbidden fruit. The pomegranate is another popular fruit symbol used in Christian art.

Go back and look at these paintings to see how many symbols you can locate.

Your Turn

Split Self-Portrait with Symbols

Think of a few symbols to stand for your personality traits and your likes and dislikes. Now, draw the face shape below on a separate sheet of paper. Fill in one side of the face with a portrait that captures your likeness and the other side just with images that symbolically represent you.

Arresting Scenes

Images of Capture in Art

Inspiring Strength

European artists commonly made art featuring scenes from the life of Jesus and saints to inspire Christians, encourage prayer among them, and even recruit new followers. Often the moment illustrated would be a challenging or difficult one, which was meant to urge followers of the religion to hold strong to their beliefs, even in the face of hardship. The arrest of an important religious figure is the subject of *The Arrest of Saint Engracia* by Spanish artist Bartolomé Bermejo. Artists around Europe represented these types of subjects with subtle differences that varied from region to region and even from artist to artist.

Bartolomé Bermejo (active 1468–1501).
The Arrest of Saint Engracia, ca. 1474–77.
Oil on panel, transferred to panel.

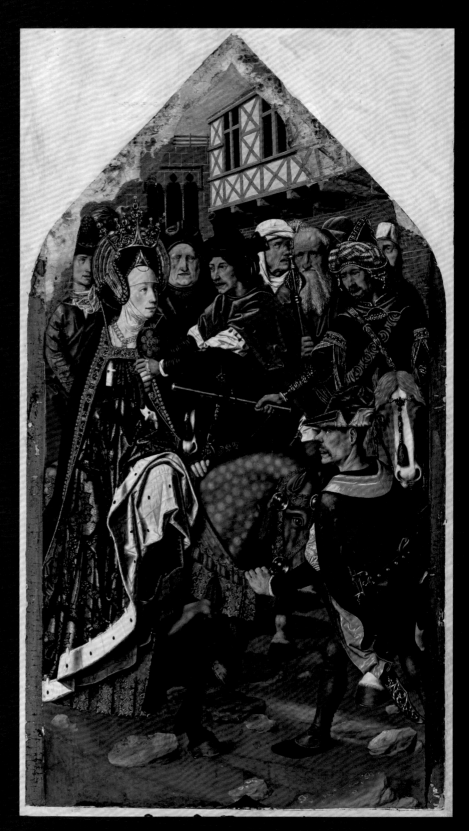

A Saintly Entrance

This work by Bermejo, *The Arrest of Saint Engracia*, tells us the story of an important saint's capture and arrest. Saint Engracia, born in Portugal, was engaged to be married to a nobleman in Spain. She was riding on horseback with her entourage to meet her fiancé when they entered the town of Zaragoza, Spain, where a Roman governor was persecuting Christians. She was arrested while attempting to protect other Christians, and then tortured and killed. Here, she is a vision of peace amidst the turmoil of the scene, and her poise is a marked contrast to the aggressive poses and gestures of her attackers. Notice the individual faces of those in the crowd surrounding the saint—each person's features are clearly defined and highly detailed. They almost look like caricatures! Saint Engracia's **attributes**, a palm and a spike, were shown on another panel of this **altarpiece**, parts of which are now scattered around the world.

Bermejo's composition appears jumbled and chaotic. Can you figure out the ordering of figures in the space in this painting—which figures are in front of which?

Can You Find?

Three horses.

From North to South

Notice the rich, jewel-like tones and tight **composition** of these two paintings. Bermejo was influenced by artists from what later would be Hieronymus Bosch's homeland, the Netherlands, where **oil painting** was first developed. Bermejo borrowed this technique to achieve the vibrant, lustrous colors seen in this work— a contrast to later Spanish paintings, which were often darker. If you compare this painting by Bermejo to the work of Valdés Leal and Zurbarán (see pages 33–34), you will notice the brighter, more intense color palette.

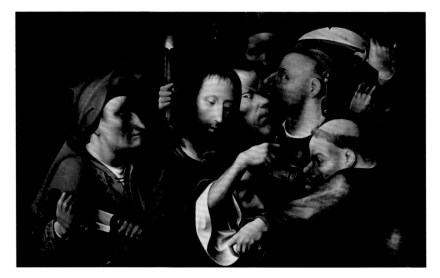

Workshop of Hieronymus Bosch (ca. 1450–1516). *The Arrest of Christ*, ca. 1515. Tempera and oil on panel.

Capturing the Mood of the Arrest

This painting represents a common subject in Christian sacred paintings: the arrest of Jesus, the event which would lead to his crucifixion. The artist or artists employed in the workshop of the Netherlandish painter Hieronymus Bosch bring to the scene a strong sense of mood. All of the key figures are included in this painting, but the artist is most interested in the feeling he creates for us, the viewers. He has crushed all of the bodies on top of one another in the composition, so close together as to make us feel the confusion, discomfort, and emotion of the moment. Among the faces, we see monstrous, cartoon-like expressions of wildness, anger, and pride, dramatically offset by the black background. Judas, known as the disciple who betrayed Jesus to his enemies, looks out at us with a bold gaze. Peter, another disciple of Jesus, holds his sword high in the air, ready to bring it down on Malchus, a slave biting his arm. Surrounded by the other six figures in the middle of the work, Jesus is the only person whose face expresses calm, despite what is happening to him.

Can You Find

The black sheath that held Peter's sword.

Can you tell what emotion each face in the crowd is meant to convey?

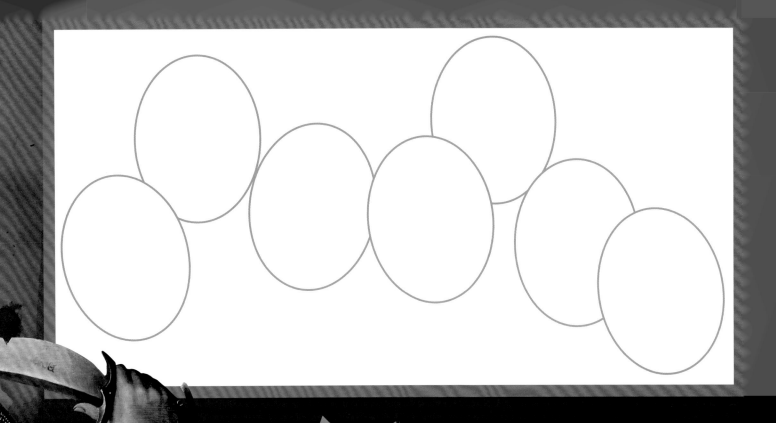

Your Turn
Create a Cartoon Crowd

Explore Bermejo and Bosch's use of tight composition and exaggerated expressions by creating your own work of art representing a packed crowd. In the space above, fill in each of the ovals with faces full of exaggerated, cartoonish expression.

Did You Know?

Bosch was one of the first artists ever to make drawings instead of paintings as independent, finished works.

Winged Ones
Angels in Christian Art

Watching for Angels

Angels have appeared in works of art for centuries. Angel-like beings first appeared in ancient Greek art and are thought to be the inspiration for the popular image of angels seen in much of the Christian art from the fifteenth and sixteenth centuries in Europe. There are several typical features of angels from this period that can help us find them in works of Christian art. Angels are generally painted wearing robes of white or various bold colors. They often have a halo above their heads, are surrounded by some kind of glowing light, and have bird-like wings on their backs. Cherubs, child-like angels, are sometimes represented as winged heads without bodies, such as those found in *The Visitation* by Valdés Leal (see page 34). Angels rarely stand alone in a work of Christian art, but are most often found floating above or sometimes next to depictions of holy figures such as the Virgin Mary, Jesus, and saints. Music is said to be the speech of angels, and for this reason, images of angels often show them making music, either with instruments or their voices.

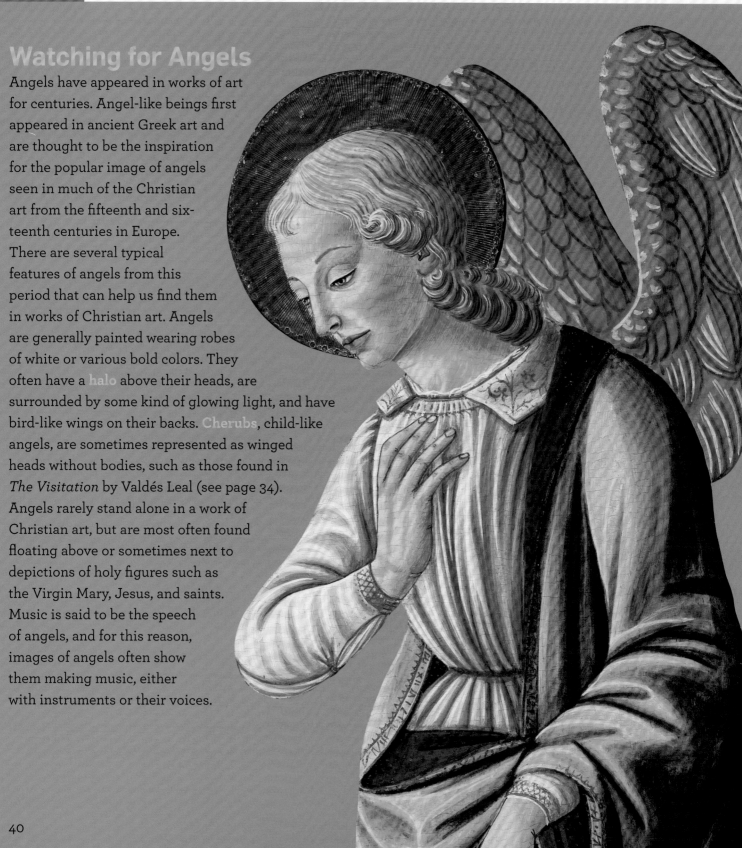

Just a Piece

Before finding its way into a museum, *Kneeling Angel*, painted around 1480 by Florentine artist Bernardo di Stefano Rosselli, was in a very different location—a church, most likely, before it was cut from a larger altarpiece or painting. Cutting works apart was a fairly common practice among later dealers of Renaissance art as a way to make more sales, thereby maximizing their profits.

It appears that the artist Rosselli and his workshop may have been working quickly on this piece, as there are a few drips of paint found running down the drapery. Although Florentine artists were typically meticulous about their craftsmanship, this work would have been displayed high up on the wall, keeping its imperfections out of sight.

Did You Know?

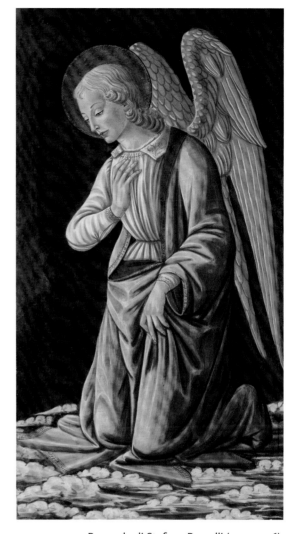

Bernardo di Stefano Rosselli (1450–1526). *Kneeling Angel*, ca. 1480. Tempera and oil on panel.

Can You Find?

The clouds.

Look Out Below

Typical of angel paintings created in the fifteenth century, this painting shows the angel kneeling on a bed of clouds, a prominent feature that the artist took great care in creating. The original paint has faded over time and made the clouds appear greener than the color they once were—a bright white. As we can see, the angel in this work is looking down below the clouds, most likely at an image of the Virgin Mary or a saint originally positioned below.

Heavenly Music
Images of Music in Renaissance Altarpieces

Angels We Have Heard

What better way to celebrate an occasion than with music! These two late Renaissance altarpieces depict religious events from the Bible. *The Coronation of the Virgin* shows the Virgin Mary being crowned by God, and the *Mystic Marriage of Saint Catherine with Saints and Angels* depicts an event in which Catherine vows her faith to Christianity. Angels play heavenly music to accompany each scene. Music represents a celebration of celestial themes and symbolizes harmony of earth with the heavens. As altarpieces, these paintings would have originally been experienced with musical accompaniment inside a church, though religious music at that time was almost entirely sung.

Can You Find?

A gold ring (see gatefold).

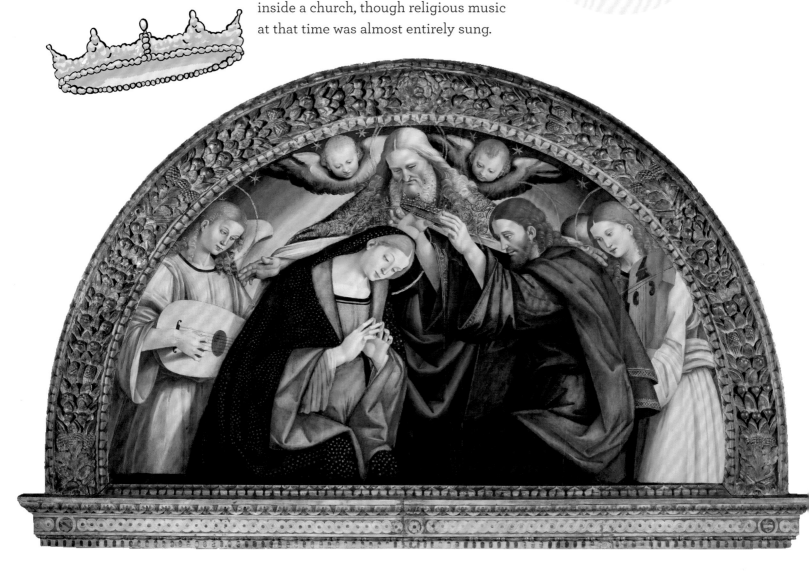

An Early Guitar

In the work of art by the workshop of the Master of Frankfurt, one of the angels plays a lute to celebrate the marriage of Saint Catherine. The lute, a pear-shaped instrument that was precursor to the modern guitar, was commonly played during the Renaissance. Its neck is bent backward at the peghead, and over the years it has gone through modifications of the number of strings from four in the Middle Ages to thirteen by the 1600s. Lutes are plucked with the fingers or played with a plectrum, which is a handheld pick. It is believed that the lute was inspired by the *'ud*, a similar stringed instrument from the Middle East. It wasn't until the nineteenth century that the guitar became the stringed instrument of choice, and many lutes were converted to guitars at this time.

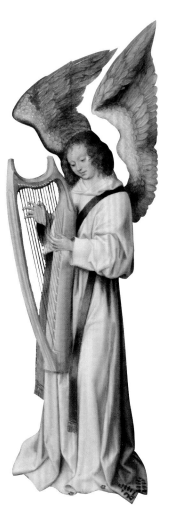

Did You Know?

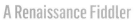

The harp is an ancient instrument. More than two thousand years ago, the Egyptians played harps for entertainment at the royal court, during ceremonies or rituals, and to mark important military events.

A Renaissance Fiddler

The Renaissance fiddle that one angel plays in *The Coronation of the Virgin* appears to be a viola or a *lira da braccio*. This instrument had six sets of strings that were played with a horsehair bow. The violin as we know it today developed from these instruments by the late sixteenth century in northern Italy.

Your Turn

Making Angelic Music

These angels seem to have lost their instruments. Using the instrument stickers provided in the back of the book, create a symphony of sounds for this Renaissance ensemble. Draw in your own musicians to provide accompaniment and complete the ensemble.

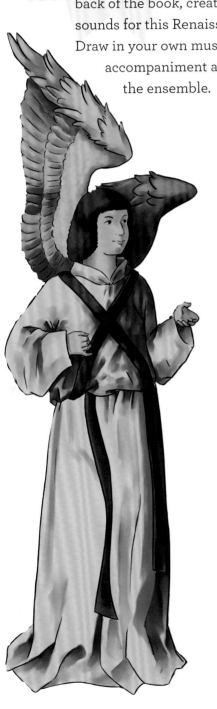

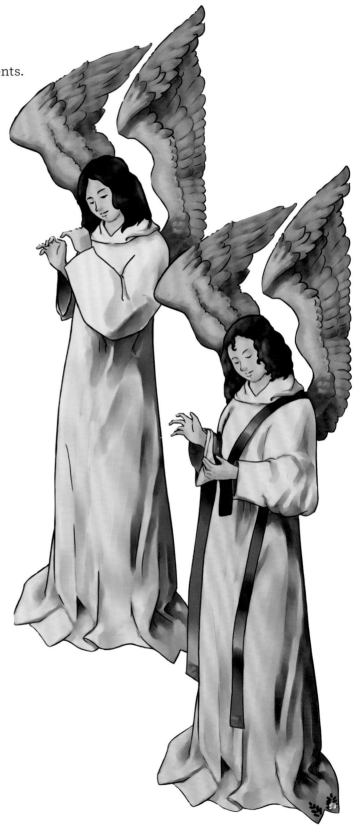

Saints and Symbols
Saints in Sacred Imagery

Saintly Figures

Religious imagery of the Renaissance illustrated stories from the Bible and from church history. These paintings and sculptures decorated places of worship and were especially useful for those who were unable to read, though they often expressed complex meanings to the more educated public as well. For this reason, the depiction of saints is a significant theme in the history of European art. Symbols indicate which saint is shown and remind us of events from the story of each figure. Most saints are shown with a golden halo to indicate their status as holy figures. The halo originated in ancient Greek and Roman art, and also is used to designate sacred figures in art from other religions, such as Buddhism, Hinduism, and Islam. In addition to halos, other symbols and attributes help tell the saints' stories. If we look closer at these images of saints from the fifteenth through seventeenth centuries, we can discover clues about those stories.

A True Saint

Saint Francis of Assisi is one of the most highly celebrated saints in the Catholic faith, besides the Virgin Mary. The patron saint of Italy, Francis was the son of a wealthy Italian merchant and lived a comfortable life of luxury before going off to war at the age of twenty-one. Imprisoned following defeat, his view of life changed and after his release he began praying heavily, giving up all of his wealth in favor of helping the poor and the ill. Saint Francis was one of Francisco de Zurbarán's favorite subjects to paint, and here the artist shows the saint in his humble robe praying before a cross, a bible, and a skull. These symbols are reminders of Francis's faith, and he looks right at us as if to invite us to pray with him.

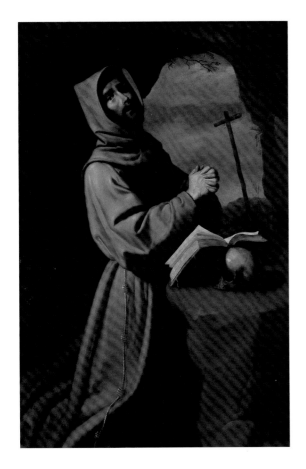

Francisco de Zurbarán (1598–1664). *Saint Francis in Prayer in a Grotto*, ca. 1650–55. Oil on canvas.

Dragon Surprise

Saint John the Evangelist was the youngest disciple of Jesus and one of the most frequently depicted saints in Christian art, after Saint Peter. Look closely at the chalice, or cup, that John holds in the painting by the Master of Saint Nicholas: a dragon is coming out of it! This attribute recalls the legend that Saint John was dared to drink from a poisoned cup. When he held his fingers up to bless it, the poison rose from the chalice in the form of a dragon or a serpent, both symbols of evil.

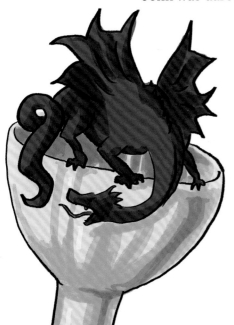

The Master of Saint Nicholas (active ca. 1465–1490). *Saint John the Evangelist and the Poisoned Chalice*, ca. 1475. Oil and tempera on panel.

The Sad Saint

This work by Spanish painter El Greco represents Saint Peter, who is clasping his hands in prayer as he looks up to the heavens. El Greco was known for an exaggerated, dramatic style. He

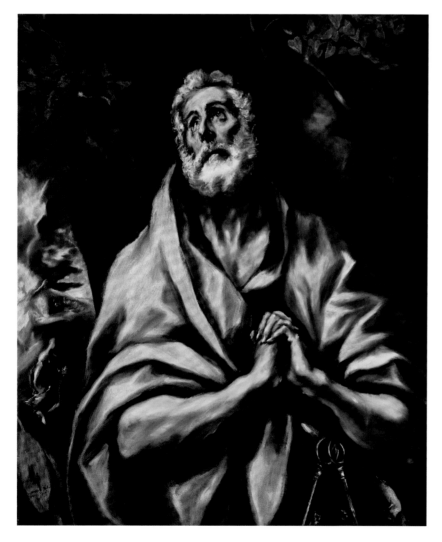

typically painted elongated bodies with stretched limbs and rippling muscles against mysteriously lit backgrounds. Saint Peter is usually pictured as he is here: with a grey beard, in a blue robe, and holding a set of keys that symbolize the keys to the gates of Heaven, which he is said to guard. Despite being one of the twelve Apostles, Saint Peter betrayed Christ: he denied knowing Jesus three times on the eve of the crucifixion, and later regretted it. We can imagine how Saint Peter must be feeling in this moody painting, with its subdued colors, as he sheds tears of sorrow.

Can You Find?

Saint Peter's keys.

Did You Know?

El Greco was so taken with the concept of penitence, or feeling sorrow over doing wrong, that he painted six versions of the penitent Saint Peter, all similar to this one.

Domenikos Theotokopoulos, called El Greco (1541–1614). *The Penitent Saint Peter*, ca. 1590–95. Oil on canvas.

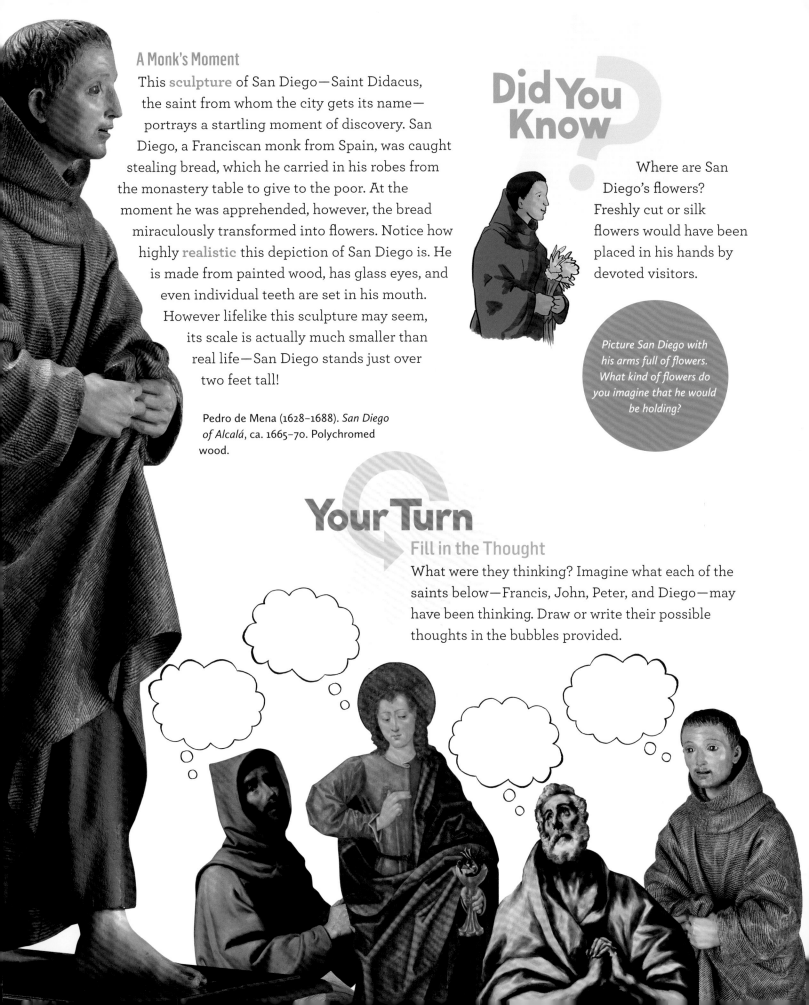

A Monk's Moment

This **sculpture** of San Diego—Saint Didacus, the saint from whom the city gets its name— portrays a startling moment of discovery. San Diego, a Franciscan monk from Spain, was caught stealing bread, which he carried in his robes from the monastery table to give to the poor. At the moment he was apprehended, however, the bread miraculously transformed into flowers. Notice how highly **realistic** this depiction of San Diego is. He is made from painted wood, has glass eyes, and even individual teeth are set in his mouth. However lifelike this sculpture may seem, its scale is actually much smaller than real life—San Diego stands just over two feet tall!

Pedro de Mena (1628–1688). *San Diego of Alcalá*, ca. 1665–70. Polychromed wood.

Did You Know?

Where are San Diego's flowers? Freshly cut or silk flowers would have been placed in his hands by devoted visitors.

Picture San Diego with his arms full of flowers. What kind of flowers do you imagine that he would be holding?

Your Turn

Fill in the Thought

What were they thinking? Imagine what each of the saints below—Francis, John, Peter, and Diego—may have been thinking. Draw or write their possible thoughts in the bubbles provided.

Seeing Double
Two Versions of Saint Jerome

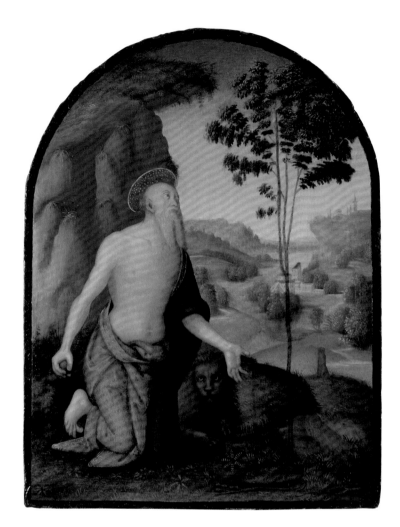

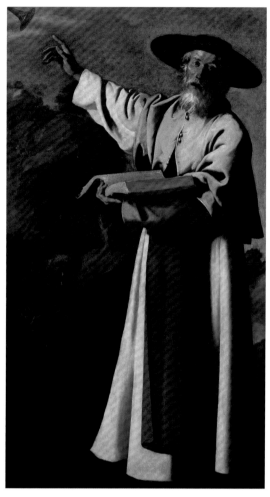

The Lion, the Saint, and the Wilderness

Saint Jerome, who left his home and his job as a scholar to fast and pray in the wilderness for four years, is another popular subject in Christian art. Both of these paintings show the saint living far from civilization as a hermit, where only a lion accompanies him, but note the differences: The picture by Francisco de Zurbarán on the right shows the saint dressed in the garb of a cardinal with the brown and white robes of a Spanish monk, while the painting by Pietro Perugino depicts the kneeling saint as a more humble figure. Also, notice how the background contrasts between these two paintings. In one, he is shown amidst a vast, sunlit landscape, and in the other, he is standing against darker, craggier scene.

ABOVE LEFT
Pietro Perugino and workshop (ca. 1450–1523). *Saint Jerome in the Wilderness*, ca. 1510–15. Oil on panel.

ABOVE RIGHT
Francisco de Zurbarán (1598–1664). *Saint Jerome*, ca. 1640–50. Oil on canvas.

Can You Find

A trumpet.

The Trumpet Shall Sound…

The trumpet that Saint Jerome points toward in the work by Zurbarán is an important **symbol**. He is hearing the trumpet sounding from the heavens, indicating that the Last Judgment is coming. It reminds him to pray—he holds the Bible open—and is intended to inspire viewers to pray as well.

A Lion for Company

After taming a lion by removing a thorn from its paw, Saint Jerome and his new companion ventured into the wilderness. Both of these works feature a lion, which is one of Saint Jerome's **attributes**, though the lion is depicted differently in each picture.

Which lion seems fiercer and which seems friendlier? Why do you think a lion was chosen for the story as opposed to a different animal?

Did You Know?

Before **conservation**, Perugino's Saint Jerome appeared to gaze blankly into a tree. Saint Jerome would normally be praying in front of a cross, so this puzzled art historians. Had the artist made a mistake or not fully understood the subject? Conservation treatment revealed gold rays emanating from the tree once the varnish and overpaint were removed. This led scholars to search for and find an early twentieth-century photograph of the painting that showed a crucifix in the tree. Someone had deliberately painted over it!

Your Turn

Where is Saint Jerome?

The setting can be crucial to the significance of a story. See how this story's meaning would change if Saint Jerome were in a different setting. Using pencils or markers, create a new background for Saint Jerome. You can photocopy this page first to try making multiple versions of the scene.

10 Pictures Come to Life
High Renaissance and Baroque Portraiture

Painting with Personality

Beginning in the **High Renaissance** and following into the **Baroque** era, **portraitists** began to paint in a way that showed their **sitters'** feelings and personalities—not just their social status. They also explored how the use of rich, deep color and intense light and dark shadows could create mood in their works. Portraits made during this time captured more movement than earlier Renaissance works had, with sitters painted in more natural poses—looking as they might in real life. Although working in different countries and over one hundred years apart, sixteenth-century Venetian painter Giorgione and seventeenth-century Dutch painter Frans Hals were two artists who experimented with—and mastered—these exciting new techniques.

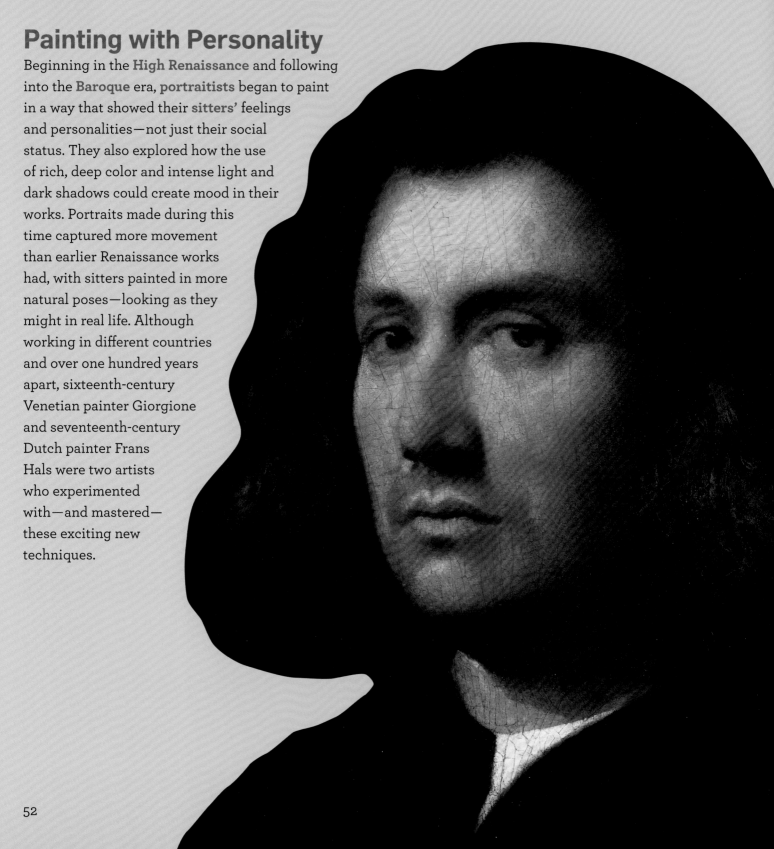

Mood and Mystery

Giorgione created smoky and shadowy effects in his paintings, which gave them a powerful mood. The mysterious expression of the sitter in this painting is much like the one found in Leonardo da Vinci's famous portrait *Mona Lisa*, created only a few years earlier. Like Bernardino Luini (see page 26), Giorgione was likely influenced by Leonardo and his work when he visited Venice in 1501.

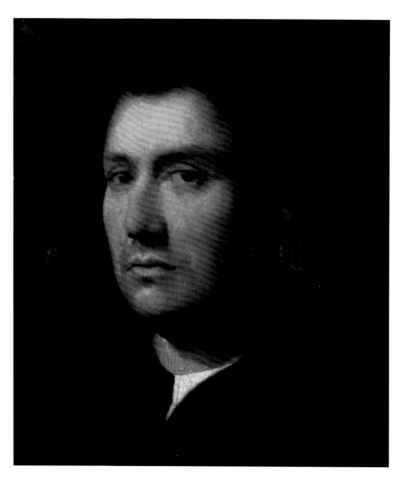

Giorgione (1477 or 1478–1510). *Portrait of a Man (known as the "Terris Portrait")*, 1506. Oil on panel.

A Modern Master

Giorgione was considered an innovative artist in his time. Unlike many of his contemporaries, he used oil paints, introduced to northern Europe in the late fifteenth century but at the time still very new to artists working in Italy. In this work, his mastery of oil paints allowed him to create realistic details, such as the fullness and softness of the sitter's hair.

Did You Know?

The dark tunic (a loose jacket-like garment) that the sitter is wearing was once a rich purple. The color has aged and darkened over time. How would your impression of this man change if he were wearing bright purple instead of black?

Friendly Faces

Portraits were traditionally reserved almost exclusively for wealthy patrons. By the Baroque period, painters had also begun to take an interest in portraits of more common people. Giorgione's painting here is of an unknown sitter, but it might be the doctor of the artist Titian, who was Giorgione's student. Frans Hals was friends with Isaac Massa, whose portrait is on the following page, and closely connected with his family.

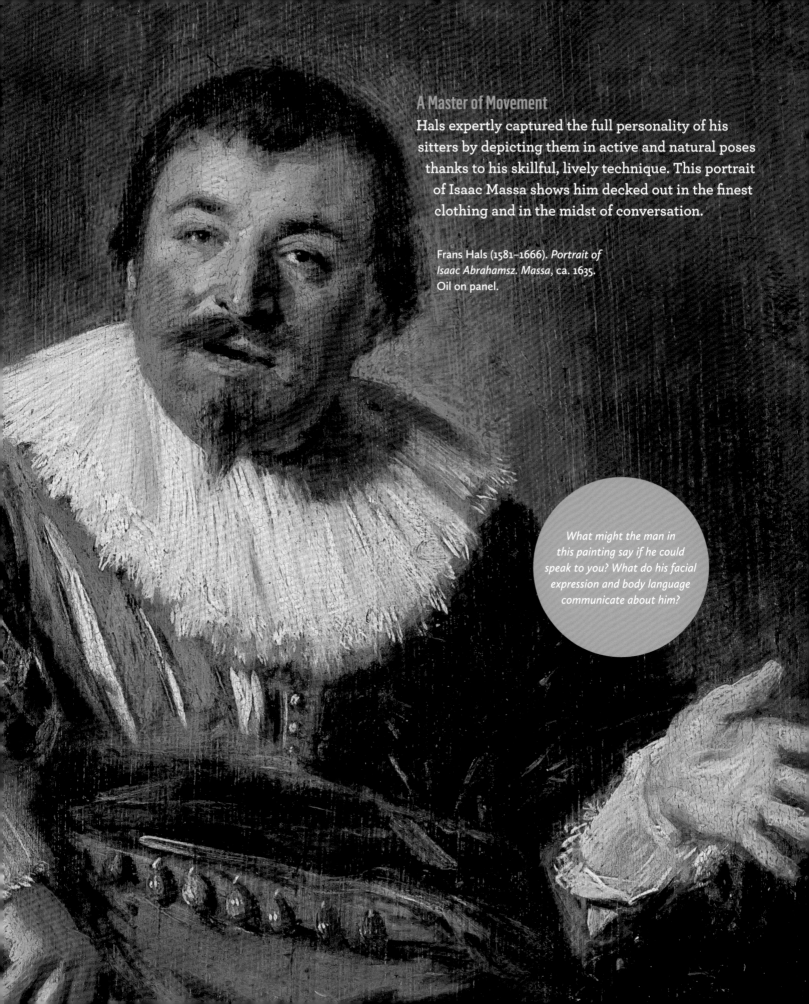

A Master of Movement

Hals expertly captured the full personality of his sitters by depicting them in active and natural poses thanks to his skillful, lively technique. This portrait of Isaac Massa shows him decked out in the finest clothing and in the midst of conversation.

Frans Hals (1581–1666). *Portrait of Isaac Abrahamsz. Massa*, ca. 1635. Oil on panel.

What might the man in this painting say if he could speak to you? What do his facial expression and body language communicate about him?

Hals was famous for painting with loose and animated brushstrokes, which give his works a sense of movement, as well as the impression of having been made very quickly. His energetic approach to painting inspired techniques used by later nineteenth-century artists like Édouard Manet and Vincent van Gogh.

Your Turn

Quick Pose Portrait

Challenge yourself to try a **gesture drawing**—a drawing that is done quickly (usually in one minute or less) intended to capture the essence of a subject and to help the artist loosen up. Find someone to draw and have him or her select a pose. In a time limit you choose, quickly draw just the essence of the person without worrying about the details. Try to keep your hand moving the whole time!

55

More Than Just a Bowl of Fruit

A still life is a picture of inanimate objects such as vases, food, plant life, or other things found around the home, the artist's studio, or even from the imagination. Still-life art has been practiced by artists for centuries, but it wasn't until the early seventeenth century in Europe that still lifes were seen as an acceptable genre, or subject type, for an artist to paint. During the Baroque period in Europe—when artists were creating innovative works that included a sense of movement, drama, and even surprise—master painters from countries like Italy, France, Holland, and Spain began creating still-life scenes with the same sophistication they brought to their other work. Just like the figural works of this time, inanimate objects were suddenly painted with astonishing realism and richness.

Fooled You!
Trompe L'oeil Still-Life Painting

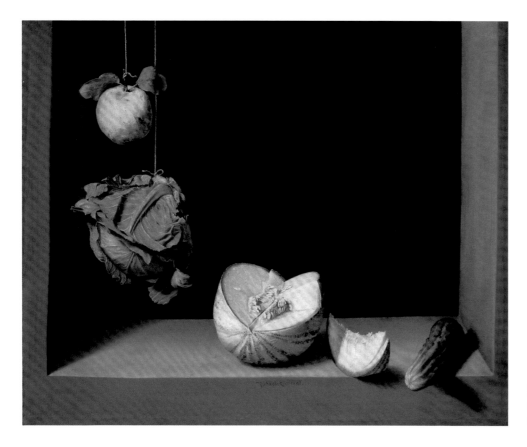

Juan Sánchez Cotán (1560–1627). *Quince, Cabbage, Melon, and Cucumber*, ca. 1602. Oil on canvas.

Can You Feel It?

A feel-good feature of these truly believable works is the representation of textures so seemingly real that you might think you can touch them. Dutch artist Samuel von Hoogstraten's *Feigned Letter Rack and Writing Implements* (on the next page) is a collection of objects with incredible visual textures: dull, metallic scissors; a quill pen with a soft, feathery top; delicate light-weight papers; and the slick, shiny handle of a letter opener. Spanish artist Juan Sánchez Cotán's painting *Quince, Cabbage, Melon, and Cucumber*, recognized as one of the greatest still-life paintings ever made, provides not just an opportunity to look at objects but to experience them: Delight in the quince, an apple-like fruit painted here with the soft and slightly bruised surface of the real thing. Look closely to see the seeds sliding down the side of the juicy, freshly cut melon. You can imagine what each of the painted objects might feel like if you could touch them.

Did You Know?

All of Sánchez Cotán's still-life paintings use this same window as a setting. It allowed him to spotlight the objects, as if on a stage. This **compositional** device was new at the time and then widely borrowed by later artists.

Seems So Real

When you first saw these images, did you think that you were looking at real vegetables and fruits, real paper and writing implements? These two paintings are great examples of **trompe l'oeil**, French for "fool the eye," which is a style of painting that creates the illusion of real three-dimensional objects. The art of trompe l'oeil began in ancient Greece and Rome and was reinvented during the Renaissance along with **perspective**, a technique for creating the illusion of three dimensions on a two-dimensional surface. Artists such as Sánchez Cotán and Von Hoogstraten were leaders of the use of trompe l'oeil in the still-life painting movement during the seventeenth century. These artists achieved the effect by using objects from real life, placing their objects in believable settings, and depicting them life-size with **realistic** textures. The results might fool even the most skeptical viewer!

Samuel von Hoogstraten (1627–1678). *Feigned Letter Rack with Writing Implements*, 1655. Oil on canvas.

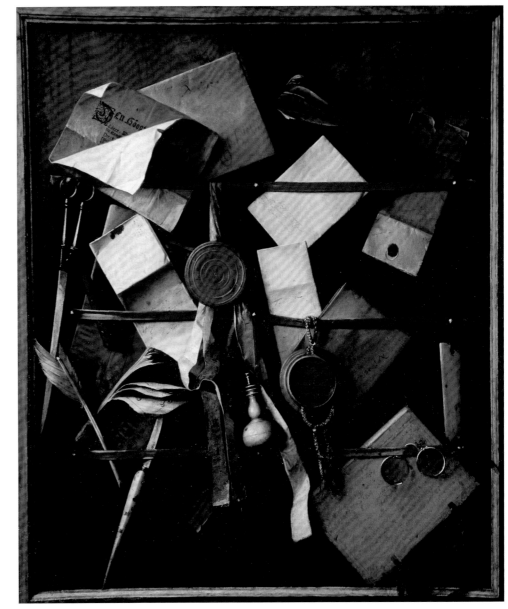

Can You Find?

A quill pen.

A Closer Look at Life

Though each painting looks like an array of objects the artist came across by chance, it was not uncommon in still-life painting for elements of the composition to be staged. Often artists aimed to give their displays a natural look by placing objects in realistic but carefully selected scenarios. For example, the articles in the letter rack are set at varying angles and even overlap one another. Rather than placing them perfectly in the rack, Von Hoogstraten has given them a more true-to-life look, as if someone has been pulling them in and out of the red bands through daily use. The casualness of the presentation helps us to believe even more that what we see is real.

What objects in the work by Von Hoogstraten can you identify, and which are no longer used today? What kind of objects might be represented instead, if this were painted more recently?

In Your Face

Notice how the cucumber appears to jut out from the edge of the window and how the ribbons fall over the side of the letter rack. It is a common technique in trompe l'oeil to include at least one object in the work that appears to project right toward the viewer's face!

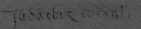

Beautiful Bouquets

In the Baroque era, floral still lifes became especially popular and refined in the Netherlands. This type of still-life art was a must-have item for art **patrons** of this time, many of whom were very interested in nature. In order to impress this nature-loving audience, Dutch still-life painters would include rare flowers and insects in their **compositions** and combine flowers from different countries and continents all in one vase. To capture their subject clearly and accurately, they would often refer to botanical texts when composing their bouquets. For this reason, their works were celebrated both as scientific studies of plant life and as beautiful paintings in their own right.

Can you identify any specific flowers in this painting?

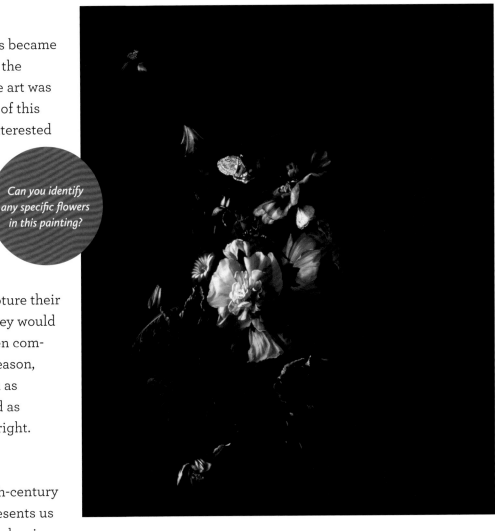

Rachel Ruysch (1664–1750). *A Vase of Flowers*, 1689. Oil on canvas.

A Natural

In *A Vase of Flowers*, seventeenth-century Dutch painter Rachel Ruysch presents us with an accurate and artistically pleasing still life of flowers and insects. Having trained in the arts from a young age, she most likely obtained her love of the natural world from her father, a botany professor. From him, she learned all about the plant life that she would later paint.

Can You Find?

A dragonfly.

The Cycle of Life

If you look closely at this still life and think like a botanist, you might notice that there is something strange going on. The painting includes flowers from different seasons, both spring and summer, and some of the flowers are dying while others hold new buds. This may be more than just a painting of a vase of flowers—it may also be about change and the cycle of life. During this time, many Dutch artists were exploring **vanitas** still life painting, in which the objects serve as **symbolic** reminders of life and death. By representing flowers in different stages, Ruysch may be reminding us that even something this beautiful is temporary, though this interpretation of the work has been debated among art historians.

Did You Know?

At a time when female artists were rarely given recognition, Ruysch enjoyed an international reputation and found great success. She was a leading artist in floral still-life painting in her time!

Your Turn
Finish the Still Life

Use your imagination to finish the still life below by drawing in your favorite flowers. Challenge yourself to create a vanitas work, showing flowers in different stages of life. Make it a baroque-style still life by incorporating a dramatic light source, active elements (like insects buzzing), and a surprise element that jumps off the page!

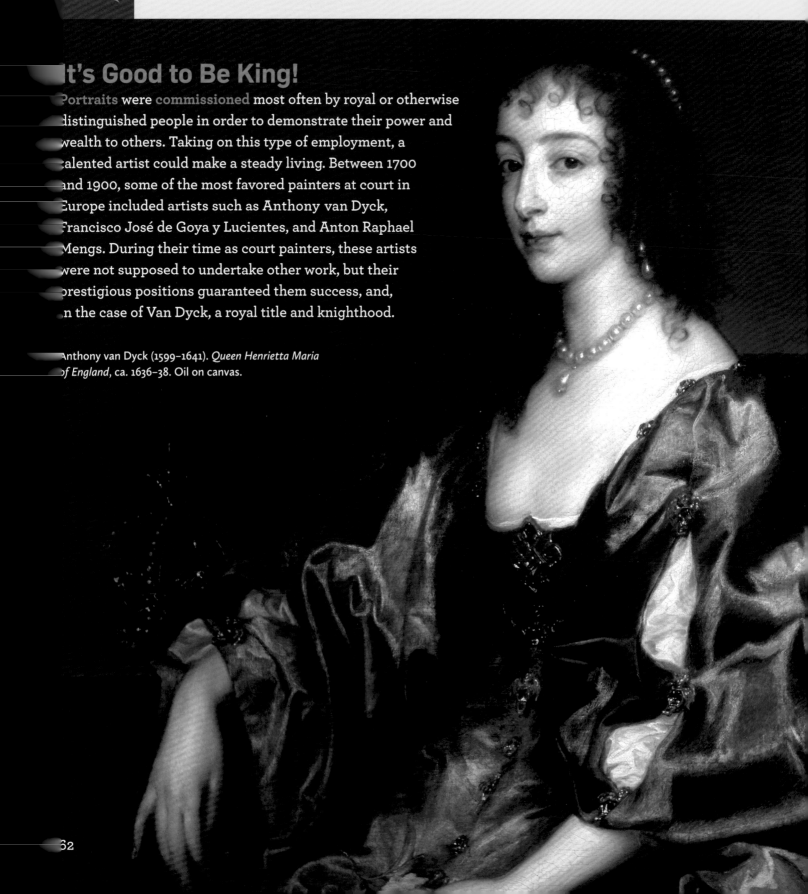

Greetings, Your Highness
Portraits of Royals and Aristocrats

It's Good to Be King!

Portraits were commissioned most often by royal or otherwise distinguished people in order to demonstrate their power and wealth to others. Taking on this type of employment, a talented artist could make a steady living. Between 1700 and 1900, some of the most favored painters at court in Europe included artists such as Anthony van Dyck, Francisco José de Goya y Lucientes, and Anton Raphael Mengs. During their time as court painters, these artists were not supposed to undertake other work, but their prestigious positions guaranteed them success, and, in the case of Van Dyck, a royal title and knighthood.

Anthony van Dyck (1599–1641). *Queen Henrietta Maria of England*, ca. 1636–38. Oil on canvas.

Dress to Impress

When posing for a portrait, a royal or an aristocrat would select his or her best outfit for the occasion. Queen Henrietta Maria of England liked dressing up for parties and important occasions, and wore a fancy dress and her pearls for this portrait. On the following pages, the portrait of the Duque de la Roca depicts the Duke in his finest clothes—his pristine uniform of the Spanish army, with some very important medals. Don Luis de Borbón, the prince of Spain, also shows off his medals in the painting to the right.

How would you choose to dress in order to impress someone looking at your portrait?

Take Thirteen!

Often working with one royal family for several years, an artist might paint the same person more than once. For example, Van Dyck painted portraits of Queen Henrietta Maria thirteen different times!

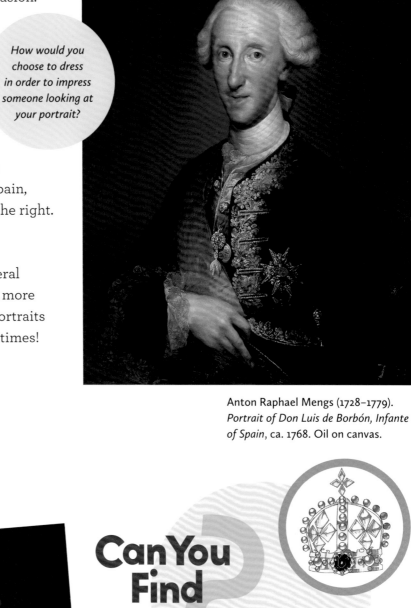

Anton Raphael Mengs (1728–1779). *Portrait of Don Luis de Borbón, Infante of Spain*, ca. 1768. Oil on canvas.

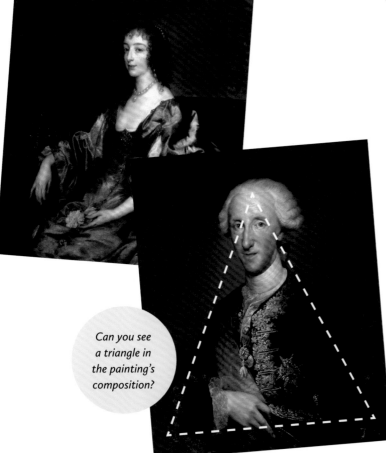

Can you see a triangle in the painting's composition?

Can You Find ?

The queen's crown.

Art and Mathematics

These artists looked to the ideas of Renaissance artists who used order, symmetry, and geometry to structure their compositions.

63

Did You Get My Good Side?

Artists like Goya and Mengs were not interested in flattering their subjects. They closely captured the Duke and the Prince's true likenesses in their portraits. It was not uncommon, however, for other artists, such as Van Dyck, to create images that idealized the appearance of the sitter to make them appear more perfect than in reality. For example, Queen Henrietta Maria was well known for having prominent front teeth, so the artist kept them out of the painting by having her pose with a close-lipped smile.

Sit Still

A person had to pose for quite a long time to have a portrait created. Fortunately, the sitter would only need to pose long enough for the artist to capture his or her face. An important person would not necessarily revisit the painter's studio when additional portraits were desired. Later works often were based on drawings from the first sitting.

If an artist were to create a portrait of you, would you want to be painted exactly as you are or would you want to be idealized? If so, how?

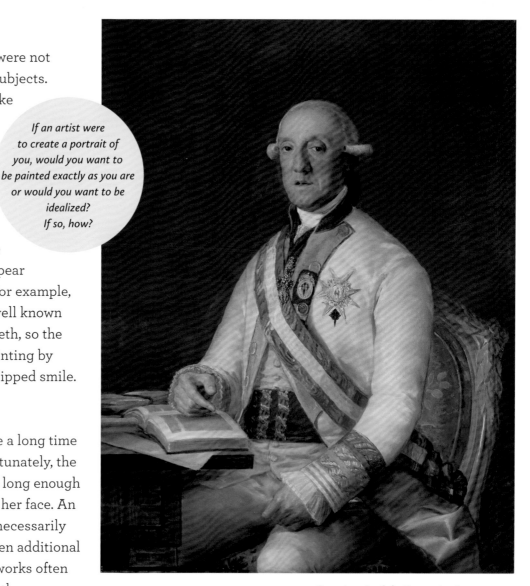

Francisco José de Goya y Lucientes (1746–1828). *Vicente María de Vera de Aragón, Duque de la Roca*, ca. 1795. Oil on canvas.

Did You Know?

One of the most important medals that many royals and high-ranking aristocrats wear is the emblem of the Golden Fleece, which is hung from a red ribbon around the neck. It means the wearer was a member a special order of knighthood. See if you can find it in any of these portraits.

Your Turn

A Royal Commission

Open the envelope to complete
an important royal commission!

Fresh Faces
Portraits of Regal Children

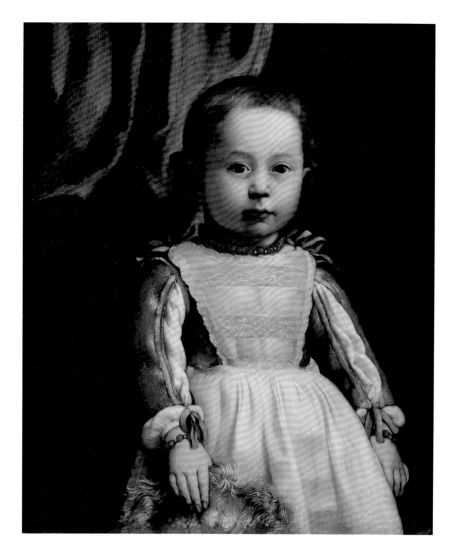

Alessandro Mattia da Farnese (1631–after 1681). *Portrait of Prince Augusto Chigi*, 1664. Oil on canvas.

When I Grow Up...

It was not uncommon for the youngest members of royal families to be painted as adults, sometimes in adult clothing. Prince Augusto Chigi of Italy, about three years old in Alessandro Mattia da Farnese's painting above, shows off an elaborate dressing gown that royal and aristocratic children wore in the eighteenth century. The young Spanish boy decked out in green and gold in Sofonisba Anguissola's portrait wears the type of hunting gear generally worn by an older person. His elegant outfit also tells us that he was an important member of the court and perhaps a future king (possibly a young Don Fernando, Prince of Spain); he wears several expensive elements such as a gold belt, medallion, and a dagger dressed in jewels.

Wear and Tear

This portrait of a young aristocrat has been through some important **conservation**. Over the years parts of the painting deteriorated, and attempts to fix it left flaws. The newer paint didn't match the older paint, and the painting was flaking. Conservators had to carefully remove the discolored parts using solvents, patch up the flaws, and re-paint it to match what the original would have looked like. Good as new!

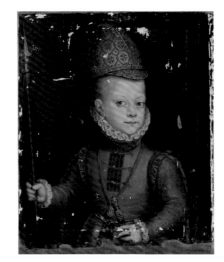 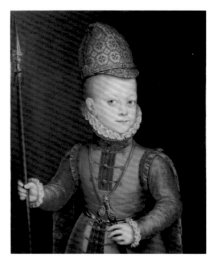

Did You Know?

Though dressed more like an adult, there is still one thing about the young boy's outfit that is appropriate to his age: What looks like a cape hanging from his shoulders is actually a set of leading straps, which would have been held by an adult to help him learn how to walk!

Can You Find?

Jewels on the dagger.

Sofonisba Anguissola (ca. 1532–1625). *Portrait of a Prince, Probably the Infante Don Fernando*, ca. 1573. Oil on canvas.

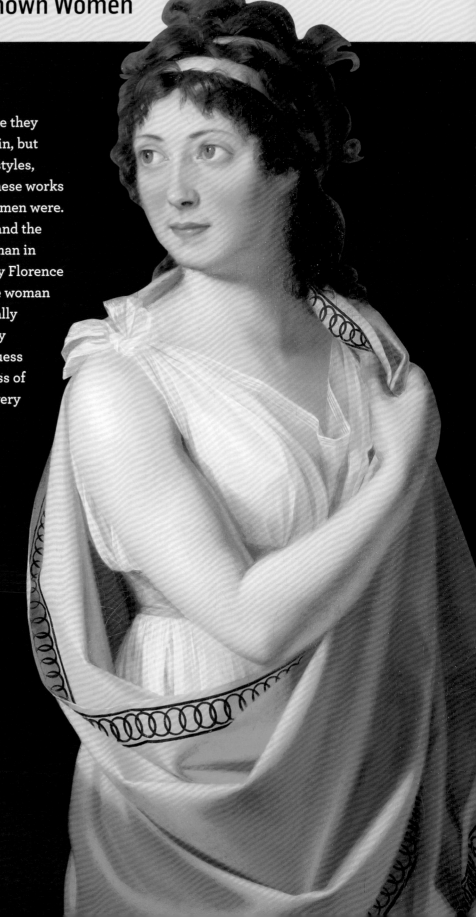

Mystery Ladies
Portraits of Unknown Women

Who's That Lady?

Who are these stylish women, and why were they painted? Their exact identities are uncertain, but through the details in their costumes, hairstyles, and other clues, we can tell when each of these works was made and gain insight into who the women were. Based on the style in which it was painted and the design of the dress, the painting of the woman in green was created in mid-sixteenth-century Florence during the Renaissance. The portrait of the woman in white, painted in France, depicts an equally elegantly dressed woman—more than likely an important person in her time. We can guess that the sitter is a noble woman: the fineness of her dress signals her wealth, and only the very wealthy could afford to have their portraits painted at this time.

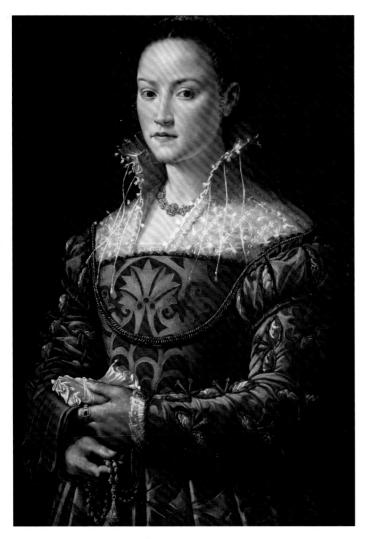

Attributed to Alessandro Allori (1535–1607). *Portrait of a Lady*, ca. 1560. Oil on panel.

Did You Know ?

The red ruby ring on the forefinger of this lady's left hand catches our eye because it is near the color green, its **complementary color** (color opposite it on the color wheel).

Let's Accessorize!

This sitter's waist is encircled by a long, decorative girdle that ends in a gold container called a musk ball. This popular Renaissance-era accessory contained perfume and was worn to protect against infection and bad smells. She holds it in her hand because she wants the viewer to see it, as it would otherwise drop to her hemline and below the edge of the painting. Also in her hands are gloves and a handkerchief, other popular fashion accessories of her time.

Can You Find ?

A musk ball.

Marks of the Masters

Painters learned from master artists, and often students inherited trademarks of their teachers. For this reason, both of these paintings were once thought to be the work of the wrong artists. The portrait of the woman in green was once attributed to the Italian master painter Agnolo di Cosimo, known as Bronzino, an artist well known for including patterns and rich textiles in his portraits. Now more art historians believe it is by Bronzino's talented student Alessandro Allori. The eighteenth-century portrait of the woman in white, originally thought to be by French master Jacques-Louis David, has features more consistent with those found in other paintings by his student, Marie-Guillemine Benoist. She inherited his love of **classical** styles and learned color techniques from Marie Elizabeth Vigée-Lebrun, another famous artist of her time.

Marie-Guillemine Benoist (1768–1826). *Portrait of a Lady*, ca. 1795–99. Oil on canvas.

Did You Know?

In the eighteenth century, female painters gained new importance, particularly in the field of portraiture. Benoist belonged to an elite circle of professional women painters and found rare success in her field, showing regularly at public exhibitions in Paris and Versailles. She was even invited to live with her family at the Louvre!

Fashionistas

Both of these mystery ladies are ready to be seen, wearing fashionable and highly desired looks for their time periods. The highly brocaded, vibrantly colored velvet gown with puffed sleeves and lace collar is representative of fashions found at court in Florence in the mid-sixteenth century, while the classically inspired Grecian dress and patterned shawl were popular in France during the late eighteenth century.

Your Turn

Classic Hair Styling

The sixteenth through eighteenth centuries saw a revival in classical hairstyles for women. These styles included up-dos decorated with pearls, precious stones, ribbons, and braids. Use the stickers provided in the back of the book to style the hair in new ways.

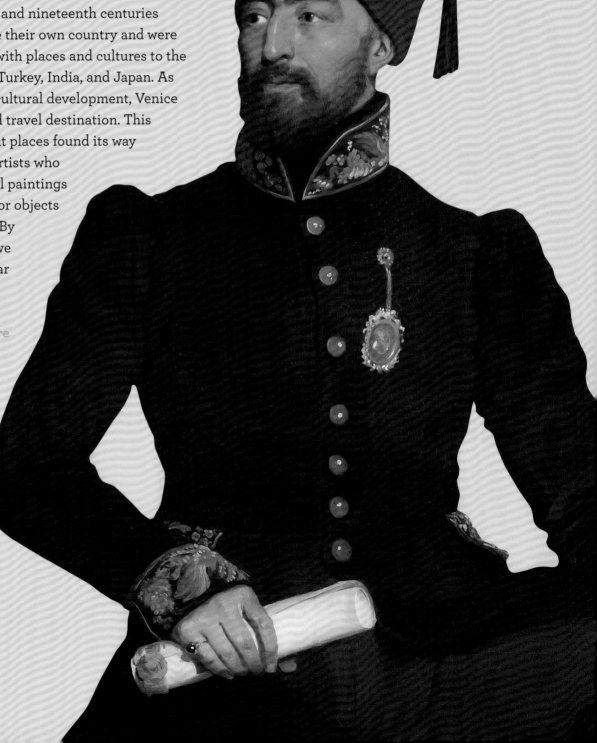

Far Away Places
Art and Travel

The Romance of Travel

Through the images they create, artists take us to places where we have never been and introduce us to new and exciting people and sights. Most Europeans in the eighteenth and nineteenth centuries had not traveled outside their own country and were particularly fascinated with places and cultures to the east and south, such as Turkey, India, and Japan. As a center of artistic and cultural development, Venice was also a much-desired travel destination. This interest in exotic, distant places found its way into the work of many artists who created rich and colorful paintings featuring foreign lands or objects representative of them. By looking at such works, we too can travel to these far away places and learn more about the people, objects, and architecture found there.

Symbols of the East

English painter George Dawe started his career in England and then traveled to Russia to create portraits of dignitaries and other individuals of high rank or office. Dawe includes many objects from Turkey in *Portrait of a Dignitary in Turkish Costume* that encourage us to better imagine the distant land. The sitter is wearing a red fez (a Turkish felt hat) and the official blue-and-gold uniform of a Turkish official. He is seated on a divan, a sofa-like piece of furniture introduced to Europe by the Ottoman Turks.

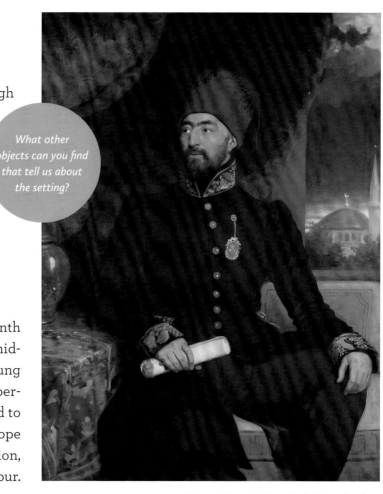

What other objects can you find that tell us about the setting?

George Dawe (1781–1829). *Portrait of a Dignitary in Turkish Costume*, early 19th century. Oil on canvas.

Did You Know?

From the mid-seventeenth century until the mid-nineteenth century, young European men of the upper-class were encouraged to take a full trip around Europe as part of their education, referred to as the Grand Tour.

Can You Find?

The central dome of the Blue Mosque.

A Special Place

The Blue Mosque is a historic monument in Istanbul, called such because of the blue tiles that surround its interior. Built in the early seventeenth century, it was and still is a popular tourist attraction as well as an active mosque for practicing Muslims. It is located next to another monumental mosque named Hagia Sophia. The two buildings are similar in size and design and their exteriors both include elements of traditional Islamic mosque architecture, such as one main dome surrounded by secondary domes and several tall, slender spires called minarets. Most mosques contain anywhere from one to four minarets, but the Blue Mosque has a total of six minarets that soar into the sky from either side of its large, central dome.

Buon Giorno, Venice!

Venetian Landscapes

A City of Water

Welcome to Venice, where the streets are made of water. These two images by Bernardo Bellotto and Francesco Guardi depict the Italian city as it was in the eighteenth century—a bustling port of canals and waterways in which boats were the main mode of transportation. Both artists carefully composed their works to reflect a certain vision of Venice. The great Venetian painter Canaletto, Bellotto's uncle and master, was taught stage design from his father. You can see that legacy in how Bellotto learned to construct a scene such as the one above, which dramatizes the comings and goings at the Molo, a large quay or a landing-place for boats in Venice where important visitors would arrive from sea. While his view of Venice is **idealized**, Guardi's (below) is more chaotic. He shows us every detail of the daily bustle that was closer to what one actually would have seen in Venice, as gondoliers stroked their small vessels through the canals and boats sailed about.

Which image of Venice would you rather visit, and why?

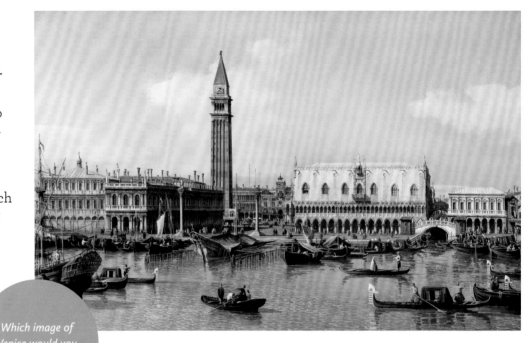

TOP
Bernardo Bellotto (1721–1780). *The Molo from the Basin of San Marco, Venice*, ca. 1740. Oil on canvas.

ABOVE
Francesco Guardi (1712–1793). *The Grand Canal with the Rialto Bridge from the South*, ca. 1770–75. Oil on canvas, lined to aluminum panel.

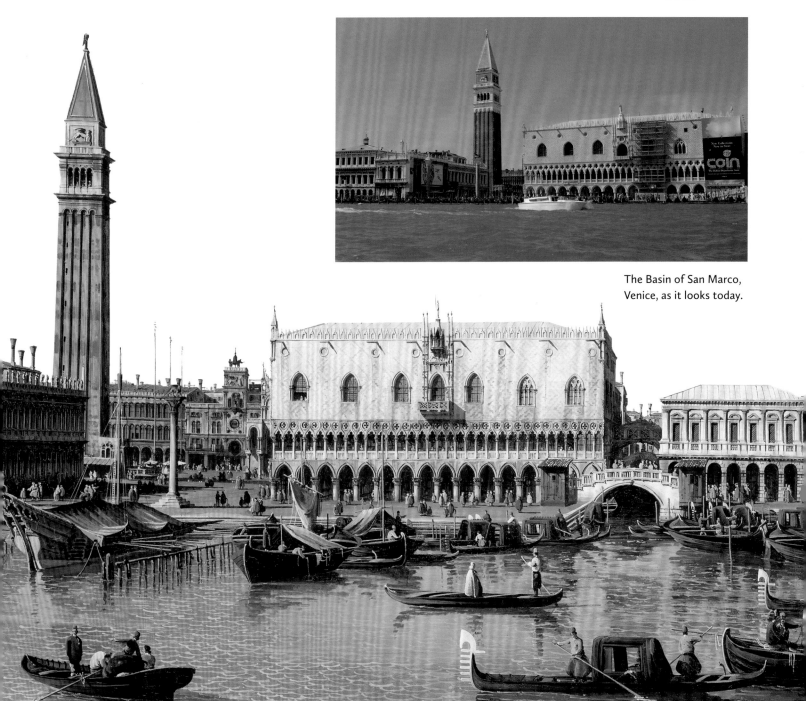

The Basin of San Marco, Venice, as it looks today.

Postcard Perfect

Bellotto and Guardi were considered two of the greatest *vedutisti,* or Italian "view-makers," who captured postcard-like images of Italy. In the eighteenth century, young English tourists would purchase or commission a painting of a favorite landscape, such as one of these by Bellotto or Guardi, to take home as a souvenir of their travels. Canaletto, Bellotto, and other artists, such as Giambattista Piranesi, also created prints of scenes that could be reproduced numerous times and sold relatively inexpensively.

Your Turn

Travel Postcard

Imagine you are selling images of your neighborhood or city to tourists. How would you design your postcard? Would you draw your surroundings realistically or would you idealize the setting? Become one of the *vedutisti* and fill out the enclosed postcard. Then put a stamp on it and mail it to a friend or family member.

Another Perspective

Italian painters beginning in the Renaissance often applied the rules of perspective to their compositions in order to create depth and give an illusion of three-dimensional space. In one-point perspective, a technique first used in ancient Rome and rediscovered in the Renaissance to mathematically order space, lines converge on a single vanishing point on the horizon line, as in this painting by Fra Carnevale. Bellotto and Guardi, however, didn't always play by the rules—they often skewed perspective to suit their compositions. Notice how Guardi's composition (below) lacks a single vanishing point. The red lines indicate the point where all lines should meet.

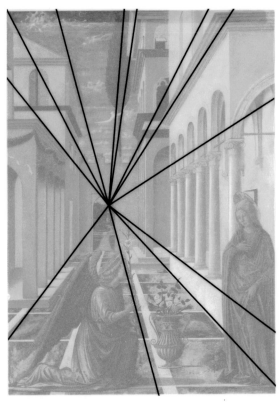

RIGHT
Fra Carnevale (active ca. 1445–1484). *The Annunciation*, ca. 1445/1450. Tempera on panel. National Gallery of Art.

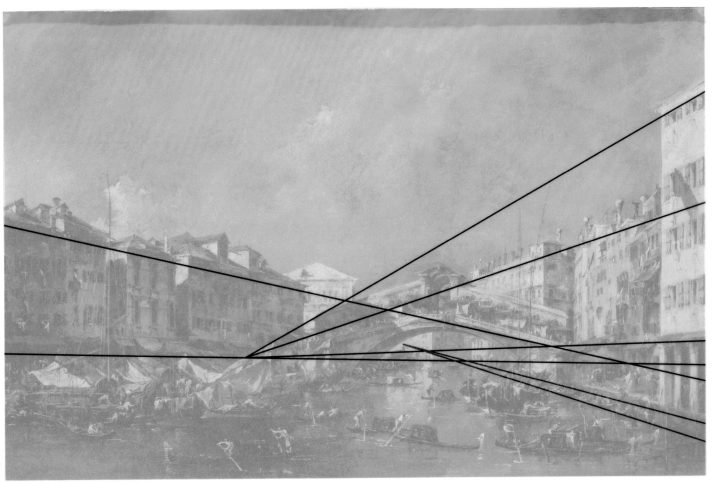

Let's Celebrate!
Parties and Dancing in European Art

A Time to Remember

Just as you might take a picture to remember a fun party, artists in the eighteenth and nineteenth centuries in Europe were eager to capture the festivities taking place around them. We can look at the images they created to better understand the way people celebrated and interacted. A close look at the detailed paintings of Venetian artist Giuseppe de Gobbis reveals some of what went on at the get-togethers of the upper class in eighteenth-century Venice. The prints, posters, and paintings of Henri de Toulouse-Lautrec give us a window into the exciting world of Paris in the late nineteenth century, when nightclubs and dance halls began springing up in town and artists flocked to them for entertainment and inspiration.

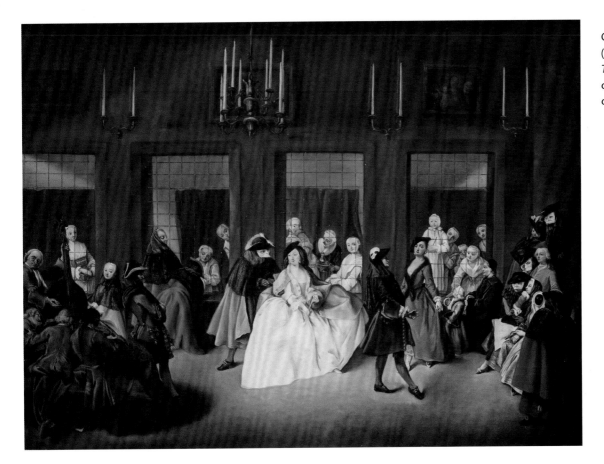

Giuseppe de Gobbis (1730–after 1787). *The Convent Parlor*, ca. 1755–60. Oil on canvas.

A Sneak Peek

De Gobbis was not an aristocrat (a member of upper class society), but he did count on the **patronage** of the aristocracy of Venice to support his career. In *The Ridotto* (on the next page), as well as other works attributed to him such as *The Convent Parlor*, he gives us a secret look into the private pastimes of high society. The masked subjects at left are busily engaged in discussions with each other—perhaps gambling, flirting, or scheming—while at the *ridotto*, which were establishments offering games and entertainment. At the time it was created, this scene would have seemed both familiar and shocking to Venetian society—a lively and playful "unmasking" of what went on behind the closed doors. Back then or today, the complicated **compositions** full of mysterious characters, activities, and objects to discover are clearly meant to entertain and delight.

Little Looks

This painting represents a series of **vignettes**, which are small stories all included in one larger work. Look around the composition at the different groups of people interacting with one another. See if you can figure out what they might be discussing, and have fun making up your own dialogue for them.

79

Have a Ball

The scene to the far right depicts a masquerade ball in late nineteenth-century Paris. Masked parties go back as far as late **medieval** court life and were originally designed to celebrate a marriage or royal event. If attending a masquerade, you would be expected to wear both a costume and a masquerade mask to partially hide your identity from the other partygoers. Wearing a mask would guarantee you entrance to the party and allow you to mix freely with the group, no matter your place in society. Masquerade costumes included both simple and decorative dresses or cloaks paired with masks of all shapes and sizes.

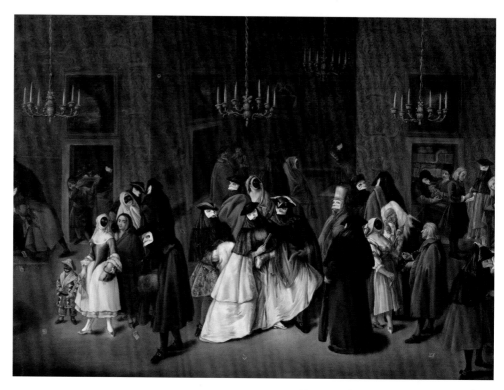

Giuseppe de Gobbis (1730–after 1787). *The Ridotto*, ca. 1755–60. Oil on canvas.

The Finest Things

The *ridotto* was a space open to the general public, but due to the formal dress code, it was mainly visited by the upper class. The above work is, in part, a social critique by De Gobbis, who was not part of that class. It exposes this semi-private location and the bad behaviors taking place within it. He depicts each of the thirty-six figures with equal attention when it comes to the rendering of the fabrics that they wear and accessories that they carry. The figures congregate in a space just as elegant as themselves, with chandeliers hanging from the large, high ceilings, paintings placed above the doorways, and walls covered with ornately patterned paper.

Your Turn
Masquerade Mask

Make your own masquerade-style mask using the cut-out shape at right. Decorate your mask in any way that you wish. Traditional masks were often highly decorated with gold, silver, crystals, and feathers and tied to the head with a ribbon or attached to a handle and held in the hand. Invite friends or family to make their own masks, and have a masquerade!

Can You Find

A waiter emerging with refreshments.

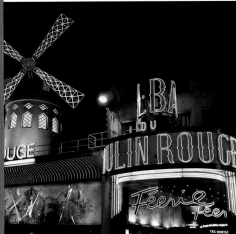

Henri de Toulouse-Lautrec (1864–1901).
The Masked Ball at the Élysée Montmartre,
ca. 1887. Oil on canvas.

Moulin Rouge, Montmartre, Paris, France,
in the evening. Photograph by Paulienne
Wessel.

Picture Perfect

Landscape painting is a tradition that became very popular in the nineteenth century in Europe. French artists such as Jean-Baptiste-Camille Corot were some of the first in Europe at this time to explore painting the landscape with a new focus on capturing nature as it was rather than depicting an imaginary or idealized version of it, as was previously popular. Before Corot, artists like Titian and Rubens would depict mythical figures like Venus lying in a scene with tumultuous skies and impossible lighting. Later, Impressionist artists such as Claude Monet and Berthe Morisot would also escape the bustle of Paris for the picturesque French countryside to capture the feeling of a fleeting moment and the effects of light and color on a scene. Morisot liked to paint along the quiet banks of the Seine River, which meandered from Paris through the surrounding rural terrain. Monet spent much of his time at Giverny, a quaint village outside of Paris where he had a country house with a lily pond and a giant, flowering garden to inspire him—one that required numerous gardeners, for whom he left detailed instructions daily!

What Time Is It?

Monet was famous for painting a subject numerous times at different times of day or season to study the changing effects of light on the subject. He painted several versions of haystacks and Rouen Cathedral in northwestern France, altering the **hues** and **temperature** of his colors each time to reflect the changing light.

Claude Monet (1840–1926). *Haystacks at Chailly*, 1865. Oil on canvas.

What time of day do you suppose it is here? Explain why you think it is that particular time.

If you were to choose one spot to paint outdoors, where would it be?

Can You Find?

Two haystacks.

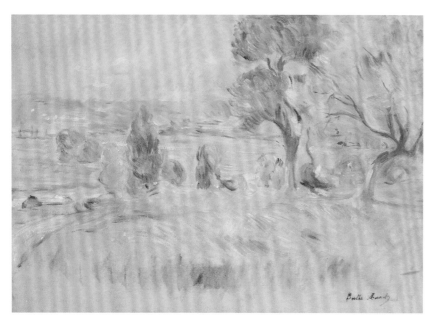

Berthe Morisot (1841–1895). *The Seine Valley at Mézy*, 1891. Oil on canvas.

First Impressions

Morisot and Monet, as cutting-edge Impressionist painters, were both well known for their spontaneous, sketch-like portrayals of the French countryside. Morisot spoke of her desire to paint as "wanting to capture something that passes; oh, just something! A smile, a flower, a fruit, the branch of the tree…." These artists often created brightly colored scenes with paints straight out of the tube (without mixing them) and used fast, **gestural** brushstrokes to portray a quickly passing view, such as a changing cloud, the color of light on the grass, or wind through the trees. That's why sometimes the works by these artists appear "unfinished"—more like a **sketch** than a painting.

Your Turn

Color Monet's Haystacks

Monet often painted the same scene at different times of day or season. Using colors of your choice, change the time of day or year of Monet's **composition**, or photocopy this page to try out several. How does your version of the scene differ from the original?

In Plain Sight

Corot, Morisot, and Monet painted *en plein air*, which is French for "in the open air." Their paintings are often small because they would carry a canvas out to a field, set up an easel, and complete a painting quickly on the spot. Sometimes they would sketch in the field first and then return to the studio to complete a larger painting. Corot, the leading artist of the Barbizon School of painting (named for the village outside of Paris where many of the group worked), explored the legendary forests of Fontainebleau, which provided miles of woodland inspiration for artists and poets (also the subject of the photograph below). He painted directly from observation of nature but was most inspired to capture an emotion or mood.

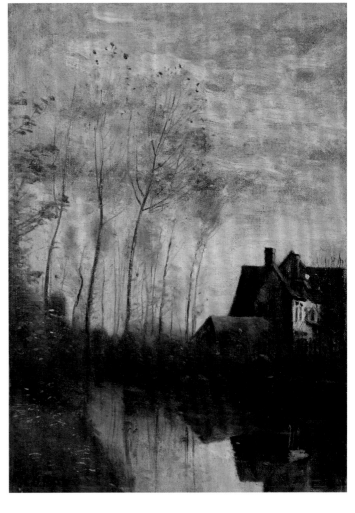

RIGHT
Constant Alexandre Famin (1827–1888). *Forest Scene*, ca. 1865. Albumen print. National Gallery of Art.

FAR RIGHT
Jean-Baptiste-Camille Corot (1796–1875). *A River Scene with Houses and Poplars*, ca. 1850–55. Oil on canvas.

Did You Know?

The paint tube wasn't invented until 1841 by an American painter named John G. Rand. This simple but groundbreaking innovation allowed artists to conveniently store their paints, and also enabled them to venture out of the studio. Before the tube was invented, artists stored their paints in pig bladders, which would often burst open!

85

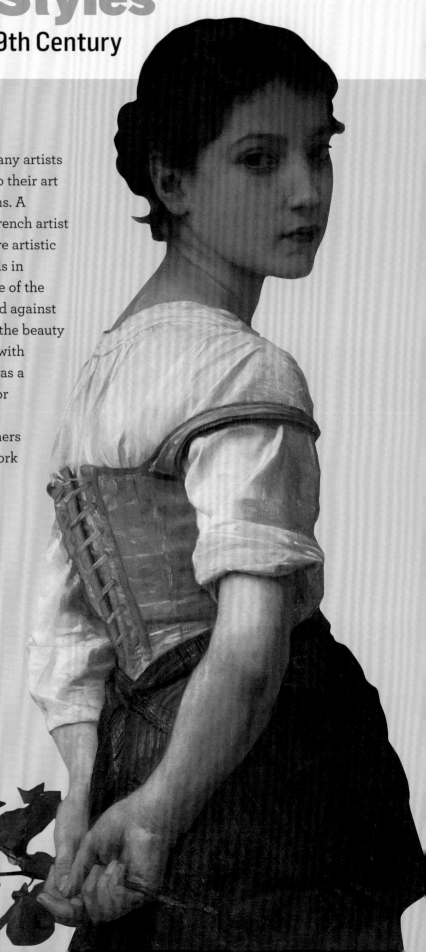

17 Clashing Styles
Art at the End of the 19th Century

Let the Battle Begin

During the second half of the nineteenth century, many artists began taking new and unconventional approaches to their art making, while others held true to academic traditions. A passionate defender of the academic style was the French artist William-Adolphe Bouguereau, who devoted his entire artistic career to painting mostly life-sized, costumed models in idealized or dream-like settings. Impressionism, one of the revolutionary new movements (see page 82), rebelled against conventional ways of painting, highlighting instead the beauty of everyday life and more experimental approaches with composition, brushstroke, and color. Edgar Degas was a leader of the Impressionists and shared their taste for depicting the beauty of real settings and people. His paintings often feature hardworking urban entertainers like ballet dancers. When viewed side by side, the work of Bouguereau and Degas demonstrate the big differences in the styles of art in Europe at the end of the nineteenth century.

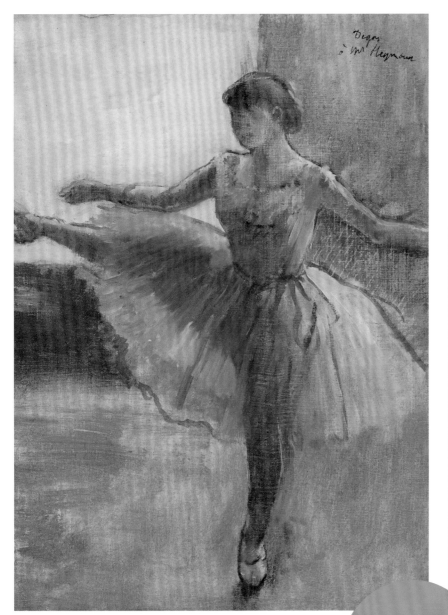

East Meets West

The nineteenth century brought an increase in Western trade with Japan, and foreign goods like art, furniture, kimonos, fans, and other items began pouring into Europe, launching a trend for everything Japanese. Woodcut **prints** by masters of **ukiyo-e** ("pictures of the floating world") in Japan transformed the work of many European artists by demonstrating that simple, everyday subjects could be presented in appealingly decorative ways. Degas was among the earliest collectors of Japanese art in France, and his own art was affected by what he saw in Japanese prints.

What similarities can you find between Degas's painting and the Hiroshige print at right?

ABOVE LEFT
Edgar Degas (1834–1917). *The Ballerina*, ca. 1876. Oil on canvas.

ABOVE RIGHT
Utagawa Hiroshige (1797–1858). *A Cool Summer Evening at Ryogoku*, from the series *Famous Places in the Eastern Capital (Toto meisho)*, 1847–51. Woodblock print.

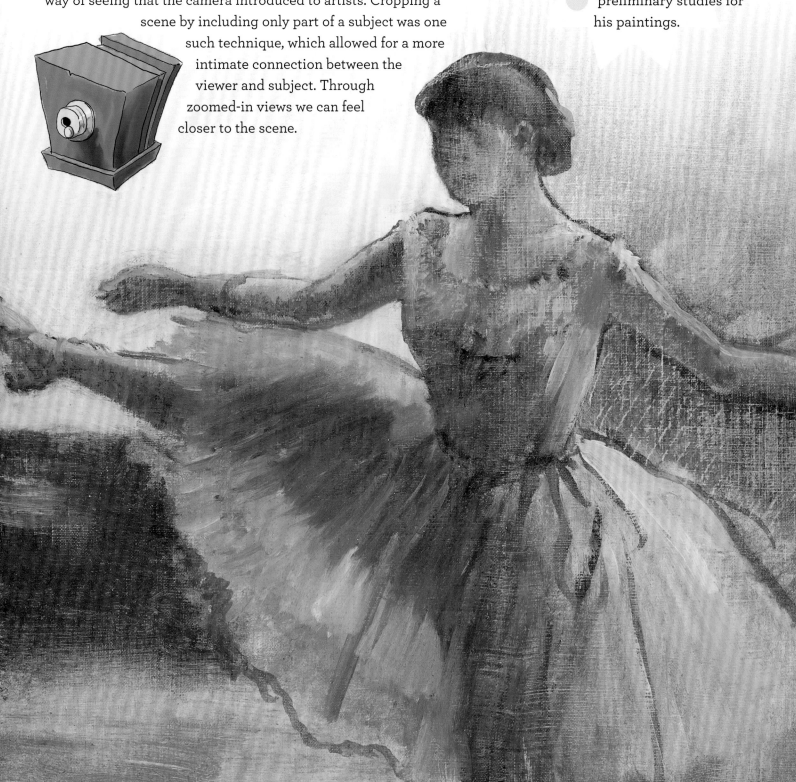

Art and Technology

The first form of photography, called the daguerreotype, was developed in the 1830s by Frenchman Louis Daguerre. By the late nineteenth century, newer camera technology was available in Europe, and it influenced the way that many artists made art. The biggest influence photography had on painting was in the new way of seeing that the camera introduced to artists. Cropping a scene by including only part of a subject was one such technique, which allowed for a more intimate connection between the viewer and subject. Through zoomed-in views we can feel closer to the scene.

Did You Know? Degas often used photographs as preliminary studies for his paintings.

Top Model

Degas was interested in painting live dancers in the studio and on stage as they practiced and performed, but Bouguereau and other traditional painters of his time preferred to create imagined scenes using models, most often women and children, dressed up as characters or types. Bouguereau's model for the *Young Shepherdess*, a young woman who appears in many of his paintings, is simply posing as a shepherdess working in a field.

What clues in the painting tell you she is not an actual shepherdess?

Did You Know?

In addition to pencil sketches, Bouguereau would create oil sketches before starting a final painting.

Look Here

A focal point is the area in the work that the artist wants viewers to notice the most. Bouguereau would often make the face of his sitter the focal point. It appears that the shepherdess's face was in fact given the most attention, as it contains the greatest amount of detail and finish.

Can You Find?

A flock of sheep.

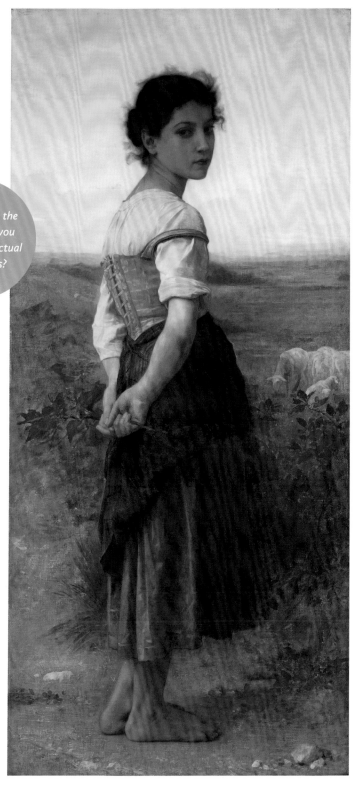

William-Adolphe Bouguereau (1825–1905). *The Young Shepherdess*, 1885. Oil on canvas mounted on board.

Your Turn

Sketching with a View Finder

A viewfinder is a tool used by artists to focus in on a particular part of a scene before drawing it. Much like a camera, viewfinders can help to crop a scene. Use the viewfinder included here to select and then sketch your own unique view of a scene. Take your viewfinder with you on your next museum visit to see the works of art in new ways!

Can you guess which details of strokes belong to which artist? Answers are at the bottom of the page.

Let's Talk Texture

If you were a painter, would you want to blend your brushstrokes or show them off? Artists like Bouguereau painted in the traditional style, in which paintings had a smooth, highly finished surface. On the other hand, Degas shared the Impressionist taste for visible strokes of paint or pastel that went in many directions.

Classic Moves

Texture does not just apply to painting. This statue by Degas was cast in bronze and has a rough, smeared surface, suggesting that the artist may have worked quickly to capture the dancer in motion. The dancer is posed in contrapposto stance, a term used in the visual arts to describe a human figure standing with most of its weight on one foot. "Contrapposto" can also be used to refer to multiple figures in art counterposed (or posed opposite) from one another.

Did You Know?

In the late 1880s, Degas's interest in sculpture increased, a shift that is often attributed to his failing eyesight—working by touch is easier with sculpture. During his lifetime, he produced hundreds of small sculptures in wax but very rarely had them cast in bronze. It was not until 1919, after the artist's death, that this work was cast in bronze by Italian sculptor Albino Palazzolo.

Imitate this sculpture and see if you can take a contrapposto stance. Then, challenge a friend or family member to take a contrapposto, or opposite, pose from yours.

Edgar Degas (1834–1917). *Dancer Fastening the Strings of Her Tights*, (1885–90, cast in 1919). Cast bronze.

ANSWERS: LEFT: Degas RIGHT: Bouguereau

Timeline

Bermejo, *The Arrest of Santa Engracia* 1474–77 SPAIN

Catena, *Holy Family with Saint A...*

Giotto, *God the Father with Angels* 1328–35 ITALY

The Renaissance begins in Italy

mid-14th century

Oil painting techniques introduced to Renaissance painting in northern Europe, perfected by Jan van Eyck

mid-15th century

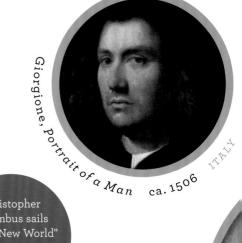

1300 **1350** **1400** **1450** **1500**

The Middle Ages

5th–13th centuries

Crivelli, *Madonna and Child* ca. 1428 ITALY

Giorgione, *Portrait of a Man* ca. 1506 ITALY

Christopher Columbus sails to the "New World" from Spain

1492

Linear perspective is rediscovered by Brunelleschi in the Renaissance

ca. 1420

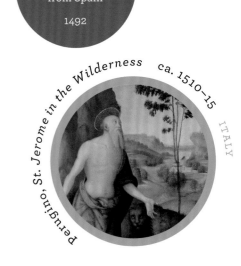

Perugino, *St. Jerome in the Wilderness* ca. 1510–15 ITALY

Br...

Checklist

All works are in the collection of The San Diego Museum of Art except those marked with an asterisk (*).

Attributed to Alessandro Allori (1535–1607). *Portrait of a Lady*, ca. 1560. Oil on panel, 28¾ × 22½ in. (73 × 57.2 cm). Museum purchase with funds provided by Anne R. and Amy Putnam, 1940.75.

Sofonisba Anguissola (ca. 1532–1625). *Portrait of a Prince, Probably the Infante Don Fernando*, ca. 1573. Oil on canvas, 23¼ × 19 in. (59 × 48.3 cm). Gift of Anne R. and Amy Putnam, 1936.58.

Bernardo Bellotto (1721–1780). *The Molo from the Basin of San Marco, Venice*, ca. 1740. Oil on canvas, 33⅝ × 57⅞ in. (85.4 × 134.3 cm). Gift of Anne R. and Amy Putnam, 1942.132.

Marie-Guillemine Benoist (1768–1826). *Portrait of a Lady*, ca. 1795–99. Oil on canvas, 39½ × 32⅛ in. (100 × 82 cm). Gift of Anne R. and Amy Putnam, 1946.5.

Bartolomé Bermejo (active 1468–1501). *The Arrest of Saint Engracia*, ca. 1474–77. Oil on panel, transferred to panel, Panel: 39⅜ × 23 in. (100 × 58.4 cm); Painted surface: 38¼ × 21³⁄₁₆ in. (97.2 × 53.8 cm). Gift of Anne R. and Amy Putnam, 1941.101.

Giovanni Bonsi (active by ca. 1350; died 1375/76). *Saint Nicholas of Bari*, ca. 1365–70. Tempera on panel, 44¼ × 25⅝ in. (112.4 × 65.1 cm). Gift of Anne R. and Amy Putnam, 1950.89.

Workshop of Hieronymus Bosch (ca. 1450–1516). *The Arrest of Christ*, ca. 1515. Tempera and oil on panel, 19⅞ × 31⅞ in. (50.5 × 81.1 cm). Gift of Anne R. and Amy Putnam, 1938.241.

William-Adolphe Bouguereau (1825–1905). *The Young Shepherdess*, 1885. Oil on canvas mounted on board, 62 × 28½ in. (157.5 × 72.4 cm). Gift of Mr. and Mrs. Edwin S. Larsen, 1968.82.

Jörg Breu (ca. 1475–1537). *Portrait of a Young Man*, ca. 1510. Oil on panel, 15¼ × 11⅝ in. (38.6 × 29.4 cm). Gift of Anne R. and Amy Putnam, 1943.26.

Barthel Bruyn the Elder (1493–1555). *Lady with Carnation*, ca. 1525–30. Oil on panel, 16¾ × 12⅝ in. (42.6 × 31.9 cm). Gift of Anne R. and Amy Putnam, 1940.73.

***Barthel Bruyn the Elder** (1493–1555). *Portrait of Scholar Petrus von Clapis*, 1528. Oil on panel, 14½ × 10¼ (37 × 26 cm). Museum of Fine Arts, Budapest.

Paolo Caliari, called Veronese (1528–1588). *Apollo and Daphne*, ca. 1560–65. Oil on canvas, 43⅛ × 44⅝ in. (109.4 × 113.4 cm). Gift of Anne R. and Amy Putnam, 1945.27.

***Paolo Caliari, called Veronese** (1528–1588). *The Choice Between Virtue and Vice*. ca. 1565. Oil on canvas, 86¼ × 66¾ in. (219.1 × 169.5 cm). The Frick Collection, New York; Henry Clay Frick Bequest, 1912.1.129.

***Fra Carnevale** (active ca. 1445–1484). *The Annunciation*, ca. 1445/1450. Tempera on panel, 34½ × 24¾ in. (87.6 × 62.8 cm). National Gallery of Art; Samuel H. Kress Collection, 1939.1.218.

Vincenzo Catena (ca. 1475–1531). *Holy Family with Saint Anne*, ca. 1510–15. Oil on panel, 34 × 53 in. (86.4 × 134.6 cm). Gift of Anne R. and Amy Putnam, 1949.76.

Jean-Baptiste-Camille Corot (1796–1875). *A River Scene with Houses and Poplars*, ca. 1850–55. Oil on canvas, 12¾ × 8⅞ in. (32.4 × 22.5 cm). Gift of The Armand Hammer Foundation, 1973.62.

Carlo Crivelli (ca. 1430/35–1495). *Madonna and Child*, ca. 1468. Tempera and oil on panel, 24½ × 16⅛ in. (62 × 41 cm). Gift of Anne R. and Amy Putnam, 1947.3.

***Leonardo da Vinci** (1452–1519). *Virgin of the Rocks*, 1483–86. Oil on panel, 78¼ × 48 in. (199 × 122 cm). Musée du Louvre, Paris, INV. 777.

George Dawe (1781–1829). *Portrait of a Dignitary in Turkish Costume*, early 19th century. Oil on canvas, 49⅞ × 36⅛ in. (126.7 × 91.8 cm). Gift of Anne R. and Amy Putnam, 1943.42.

Edgar Degas (1834–1917). *The Ballerina*, ca. 1876. Oil on canvas, 12⅝ × 9⅜ in. (32.1 × 23.8 cm). Museum purchase through the Earle W. Grant Acquisition Fund, 1976.111.

Antonio de Bellis (ca. 1616–ca. 1660). *David with the Head of Goliath*, ca. 1640. Oil on canvas, 50½ × 38½ in. (128.3 × 97.8 cm). Gift of Mrs. Harry Turpin, 1947.55.

Declaration of Independence signed July 4, granting the United States independence from England

1776

Dawe, *portrait of a Dignitary in Turkish Costume* early 1800s FRANCE

Toulouse-Lautrec, *The Masked Ball at the Élysée Montmartre* ca. 1887 FRANCE

French Revolution

1789–99

Invention of camera by Henry Fox Talbot with calotype process (Daguerreotype invented ca. 1837, Louis Daguerre)

1840

...rco, *Venice* ca. 1740 ITALY

Goya, *Vicente María de Vera de Aragón, Duque de la Roca* ca. 1795 SPAIN

Bouguereau, *The Young Shepherdess* 1885 FRANCE

1900

ca. 1795–99 FRANCE

Corot, *A River Scene with Houses and Poplars* 1850–55 FRANCE

Invention of paint tube by John G. Rand, American portrait painter—influenced Impressionists

1841

Darwin publishes *On the Origin of Species*

1859

Monet, *Haystacks at Chailly* 1891 FRANCE

Degas, *The Ballerina* ca. 1876 FRANCE

1750 1800 1850

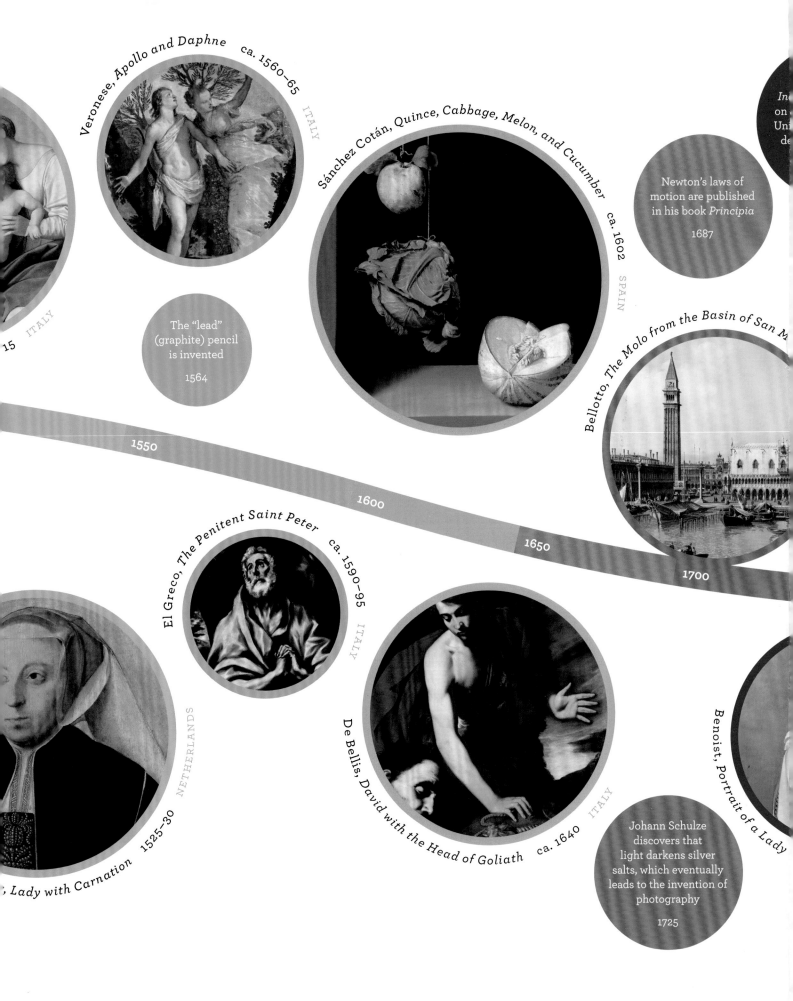

Veronese, *Apollo and Daphne* ca. 1560–65 ITALY

Sánchez Cotán, *Quince, Cabbage, Melon, and Cucumber* ca. 1602 SPAIN

Newton's laws of
motion are published
in his book *Principia*

1687

The "lead"
(graphite) pencil
is invented

1564

15 ITALY

Bellotto, *The Molo from the Basin of San M*

1550

1600

1650

1700

El Greco, *The Penitent Saint Peter* ca. 1590–95 ITALY

De Bellis, *David with the Head of Goliath* ca. 1640 ITALY

, *Lady with Carnation* 1525–30 NETHERLANDS

Benoist, *Portrait of a Lady*

Johann Schulze
discovers that
light darkens silver
salts, which eventually
leads to the invention of
photography

1725

Edgar Degas (1834–1917). *Dancer Fastening the Strings of Her Tights*, (1885–90, cast in 1919). Cast bronze, 16⅞ × 8½ × 6⅜ in. (43 × 21.6 × 16.2 cm). Gift of Mr. and Mrs. Norton S. Walbridge, 1991.12.

Giuseppe de Gobbis (1730–after 1787). *The Convent Parlor*, ca. 1755–60. Oil on canvas, 33 × 45 in. (83.8 × 114.5 cm). Gift of Anne R. and Amy Putnam, 1950.97.

Giuseppe de Gobbis (1730–after 1787). *The Ridotto*, ca. 1755–60. Oil on canvas, 33 × 45 in. (83.8 × 114.5 cm). Gift of Anne R. and Amy Putnam, 1950.96.

***Constant Alexandre Famin** (1827–1888). *Forest Scene*, ca. 1865. Albumen print, 9¾ × 7¼ in. (24.8 × 18.4 cm). National Gallery of Art; the Horace W. Goldsmith Foundation through Robert and Joyce Menschel, 2004.42.1.

Workshop of the Master of Frankfurt (ca. 1460–1533). *Mystic Marriage of Saint Catherine with Saints and Angels*, ca. 1500–10. Oil on panel, 27½ × 18¾ in. (69.9 × 47.6 cm). Gift of Mrs. Cora Timken Burnett, 1930.5.

Giorgione (1477 or 1478–1510). *Portrait of a Man (known as the "Terris Portrait")*, 1506. Oil on panel, 11⅞ × 10⅛ in. (30.2 × 25.7 cm). Gift of Anne R. and Amy Putnam, 1941.100.

***Giotto** (ca. 1267–1337). *Baroncelli Altarpiece*, ca. 1327–34. Tempera on panel, 72⅞ × 127⅛ (185 × 323 cm). Florence, Church of Santa Croce.

Giotto (ca. 1267–1337). *God the Father with Angels*, ca. 1328–35. Tempera on panel, 28⅛ × 29⅝ in. (71.4 × 75.2 cm). Gift of Anne R. and Amy Putnam, 1945.26.

Francisco José de Goya y Lucientes (1746–1828). *Vicente María de Vera de Aragón, Duque de la Roca*, ca. 1795. Oil on canvas, 42⅝ × 32½ in. (108 × 83 cm). Gift of Anne R. and Amy Putnam, 1938.244.

Francesco Guardi (1712–1793). *The Grand Canal with the Rialto Bridge from the South*, ca. 1770–75. Oil on canvas, lined to aluminum panel, 21½ × 33½ in. (54.6 × 85.1 cm). Gift of Anne R. and Amy Putnam, 1940.77.

Frans Hals (1581–1666). *Portrait of Isaac Abrahamsz. Massa*, ca. 1635. Oil on panel, 8⅜ × 7¾ in. (21.3 × 19.7 cm). Gift of Anne R. and Amy Putnam, 1946.74.

Utagawa Hiroshige (1797–1858). *A Cool Summer Evening at Ryogoku*, from the series *Famous Places in the Eastern Capital (Toto meisho)*, 1848–51. Woodblock print, 20 × 34¾ in. (50.8 × 88.3 cm). Anonymous donor, 1985.26.2.

Jean-Auguste-Dominique Ingres (1780–1867). *Study for Phidias in "The Apotheosis of Homer,"* ca. 1827. Oil on canvas, laid down on panel, 12¼ × 14 in. (31.1 × 35.6 cm). Museum purchase with funds from the Earle W. Grant acquisition fund, 1974.7.

***Jean-Auguste-Dominque Ingres** (1780–1867). *Homer Deified, or The Apotheosis of Homer*, 1827. Oil on canvas, 152 × 201½ in. (386 × 512 cm). Musée du Louvre, Paris, INV. 5417.

Bernardino Luini (1481/82–1532). *The Conversion of the Magdalene (An Allegory of Modesty and Vanity)*, ca. 1520. Oil on panel, 25½ × 32½ in. (64.8 × 82.6 cm). Gift of Anne R. and Amy Putnam in memory of their sister, Irene, 1936.23.

Alessandro Mattia da Farnese (1631–after 1681). *Portrait of Prince Augusto Chigi*, 1664. Oil on canvas, 32¾ × 29¾ in. (83.2 × 75.6 cm). Museum purchase with funds provided by the Helen M. Towle Bequest, 1938.255.

Pedro de Mena (1628–1688). *San Diego of Alcalá*, ca. 1665–70. Polychromed wood, 24⅕ × 9½ × 10⅔ in. (61.5 × 24 × 27 cm). Museum Purchase with Funds from the Estate of Donald Shira and from Anne Otterson, 2012.77.

Anton Raphael Mengs (1728–1779). *Portrait of Don Luis de Borbón, Infante of Spain*, ca. 1768. Oil on canvas, 32¼ × 23¾ in. (82 × 63 cm). Museum Purchase, 2011.133.

Claude Monet (1840–1926). *Haystacks at Chailly*, 1865. Oil on canvas, 11⅞ × 23⅞ in. (30.2 × 60.5 cm). Museum purchase, 1982.20.

Berthe Morisot (1841–1895). *The Seine Valley at Mézy*, 1891. Oil on canvas, 10⅞ × 15⅜ in. (27.8 × 39.1 cm). Gift of Mr. and Mrs. Norton S. Walbridge, 1964.117.

Pietro Perugino and workshop (ca. 1450–1523). *Saint Jerome in the Wilderness*, ca. 1510–15. Oil on panel, 11 × 9 in. (27.9 × 22.9 cm). Gift of Jacob M. Heimann, 1944.20.

Rachel Ruysch (1664–1750). *A Vase of Flowers*, 1689. Oil on canvas, 26¾ × 22½ in. (68 × 57.2 cm). Museum purchase with funds from the Gerald and Inez Grant Parker Foundation, 1979.25.

The Master of Saint Nicholas (active ca. 1465–1490). *Saint John the Evangelist and the Poisoned Chalice*, ca. 1475. Oil and tempera on panel, 34⅝ × 19⅜ in. (88 × 49.2 cm). Gift of Bertram Newhouse, 1936.47.

Juan Sánchez Cotán (1560–1627). *Quince, Cabbage, Melon, and Cucumber*, ca. 1602. Oil on canvas, 27⅛ × 33¼ in. (69 × 84.5 cm). Gift of Anne R. and Amy Putnam, 1945.43.

Luca Signorelli (1450–1523). *The Coronation of the Virgin*, 1508. Oil and tempera on panel, 50 × 87¾ in. (127 × 223 cm). Museum purchase with funds provided by the Gerald and Inez Grant Parker Foundation, Dr. and Mrs. Edward Binney, III, and Museum Art Purchase funds, 1985.59.

Bernardo di Stefano Rosselli (1450–1526). *Kneeling Angel*, ca. 1480. Tempera and oil on panel, 36¾ × 20¼ in. (114.9 × 71.1 cm). Gift of Jacob M. Heimann, 1947.45.

Domenikos Theotokopoulos, called El Greco (1541–1614). *The Penitent Saint Peter*, ca. 1590–95. Oil on canvas, 49¼ × 42⅜ in. (125.1 × 107.6 cm). Gift of Anne R. and Amy Putnam, 1940.76.

Henri de Toulouse-Lautrec (1864–1901). *The Masked Ball at the Élysée Montmartre*, ca. 1887. Oil on canvas, 21¾ × 18⅛ in. (55.3 × 46 cm). Gift of the Baldwin M. Baldwin Foundation, 1987.116.

Henri de Toulouse-Lautrec (1864–1901). *Jane Avril*, 1893. Lithograph poster, 50½ × 37 in. (128.3 × 94 cm). Gift of the Baldwin M. Baldwin Foundation, 1987.32.

Juan de Valdés Leal (1622–1690). *The Visitation*, 1673. Oil on canvas, 69⅝ × 57⅛ in. (176.8 × 145 cm). Museum Purchase with funds from Lisa and Chuck Hellerich, Dolores Clark, Dale Burgett and George Gilman, the Gildred Family, Fran Golden, Paul Mosher, and Sally and John Thornton, 2014.15.

Anthony van Dyck (1599–1641). *Queen Henrietta Maria of England*, ca. 1636–38. Oil on canvas, 42¼ × 33½ in. (107.3 × 85.1 cm). Gift of Anne R. and Amy Putnam, 1939.99.

Samuel von Hoogstraten (1627–1678). *Feigned Letter Rack with Writing Implements*, 1655. Oil on canvas, 31⅝ × 26¾ in. (80.3 × 68 cm). Gift of Jo Wallace Walker in honor of Burnett Walker, 1975.80.

Simon Vouet (1590–1649). *Aeneas and His Family Fleeing Troy*, ca. 1635–40. Oil on canvas, 55¼ × 43½ in. (140 × 110 cm). Museum purchase, 1987.124.

Francisco de Zurbarán (1598–1664). *Virgin and Child with the Young Saint John the Baptist*, 1658. Oil on canvas, 54½ × 42 in. (138.4 × 106.7 cm). Gift of Anne R., Amy and Irene Putnam, 1935.22.

Francisco de Zurbarán (1598–1664). *Saint Francis in Prayer in a Grotto*, ca. 1650–55. Oil on canvas, 62 × 39½ in. (157.5 × 100.5 cm). Gift of Conrad Prebys and Debbie Turner, 2014.132

Francisco de Zurbarán (1598–1664). *Saint Jerome*, ca. 1640–50. Oil on canvas, 73 × 41 in. (185 × 104 cm). Museum purchase with funds provided by Anne R. and Amy Putnam, 1929.45.

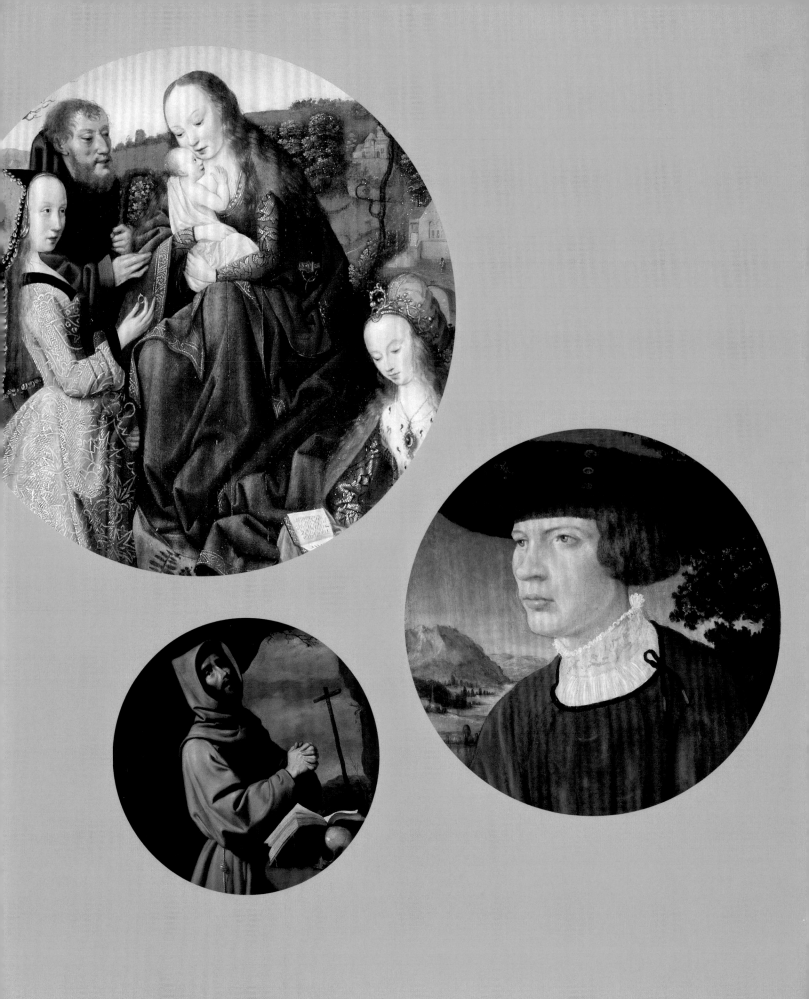

Glossary

Academic: In keeping with the values taught in art academies, which had a major influence over what styles and subjects were acceptable.

Allegory: A mode of representation in art in which characters or events stand for a hidden meaning or idea, usually of morals or values.

Altarpiece: A painting or sculpture made to adorn the altar of a Christian church.

Apprentice: A student who assists a master artist in a workshop.

Architecture: The design of buildings or structures.

Attribute: An object or feature that is used to identify a person.

Barbizon School: School of painting named for the village outside of Paris where many members worked. Artists focused on capturing nature as it was and often painted outdoors.

Baroque: A style of European art of the seventeenth and eighteenth centuries that is characterized by highly ornate details and heightened drama.

Bole: A fine, reddish-brown clay that is used to prime panels for gilding.

Camera obscura: A box or room with a pinhole in it that projects an image of objects placed before it; the forerunner of the camera.

Cherub: A child-like angel, sometimes represented as only a winged head, and thought to attend to God.

Classical: Relating to ancient Greece and Rome.

Colorist: A painter skilled in achieving special effects with color.

Commission: A work of art that an artist is hired to create specifically for a patron.

Complementary color: Colors opposite on the color wheel (red and green, yellow and purple, and orange and blue) that, when placed next to each other, create emphasis.

Composition: The arrangement of the parts of a picture.

Conservation: The practice of restoring and repairing works of art.

Conservator: A professional who repairs a work of art and restores it to its original state.

Contrapposto: A term used in the visual arts to describe a human figure standing with most of its weight on one foot; can also be used to refer to multiple figures in art posed opposite from one another.

Curator: A professional who studies art and the collections of a museum.

Daguerreotype: The first form of photography, developed in the 1830s by Frenchman Louis Daguerre.

Diptych: Two-panel painting.

En plein air: French for "in the open air"; used to describe the tradition of painting out-of-doors that became popular in France in the nineteenth century.

Focal point: The area in a work of art that the artist wants the viewer to notice the most.

Genre: Subject types in works of art (e.g., still life, portrait, landscape).

Gesture drawing/gestural: A drawing done quickly (often in one minute or less) in order to capture the essence of a subject.

Gold leaf: Gold that has been beaten into a very thin sheet and is applied to works of art in a process called gilding.

Halo: A disk or circle of light located above the head of an angel or saint in a work of art.

High Renaissance: The period of culminating values and the height of artistic achievement of the early sixteenth century.

Hue: A color or shade of color.

Humanist: An intellectual who takes an interest in the individual person, non-religious education, the arts, literature, science, and other subjects.

Idealize: In art, to make images that improve upon reality or make a subject appear more perfect.

Impressionist: A style of art that developed in France in the 1860s in which artists captured the effects of color and light in a fleeting moment.

In-painting: Painting technique done by conservators to fill in lost or damaged areas of a painting.

Journeyman: A trained worker that is employed by a master artist in a workshop.

Landscape: A work of art in which the land—usually countryside—is the primary subject.

Medieval: The period of time from the end of the classical period until the Renaissance, about the fifth century to the fifteenth century AD. Also known as the Middle Ages.

Medium: Material used to make art, such as paint, clay, wood, marble, etc.

Middle Ages: The period of time from the end of the classical period until the Renaissance, about the fifth century to the fifteenth century AD. Also known as the Medieval period.

Minaret: A tall, slender spire that is part of a mosque.

Mythological: Relating to myths.

Myths: Tales from ancient times meant to explain why the world is the way it is.

Narrative art: A work of art that illustrates a moment from a story or a complete story.

Naturalistic: Having accurately depicted objects with attention to detail.

Naturalism: The style of depicting objects accurately and with attention to detail.

Neoclassicism: An artistic style in eighteenth-century Europe that drew inspiration from classical art and culture.

Oil paint: Paint that is created by mixing pigments with linseed, poppyseed, or walnut oil as a binder.

One-point perspective: A technique developed in the Renaissance to order space mathematically with lines that converge on a single vanishing point on the horizon line.

Patron: A supporter of art, financial or otherwise, who hires artists to create works.

Perspective: An artistic technique for creating the illusion of three dimensions on a two-dimensional surface.

Pigment: A powder ground from rocks, minerals, plants, or other materials that is mixed with a binder to create paint.

Portrait: A painting, drawing, or photograph of an actual person.

Portraitist: A person who specializes in painting portraits, or pictures of actual people.

Print: A reproduction of a single original created by running a carved, etched, or engraved plate (metal, wood, or other material) through a printing press.

Proportion: The measure of relative sizes between shapes in a work of art.

Realism/Realistic: Representing things in an accurate or true way; lifelike.

Renaissance: The revival of art, literature, and other subjects from classical models during the fourteenth to sixteenth centuries, beginning in Florence, Italy, and spreading to other parts of Europe.

Sculpture: A three-dimensional work of art that has been formed by carving, chiseling, modeling, or building materials into a form.

Self-portrait: A painting that an artist creates of him or herself.

Sketch: A quick drawing.

Sitter: A person who poses for a portrait.

Still life: A picture of inanimate objects; items may include vases, food items, plant life, etc.

Study: A practice piece or quick painting created to capture a subject or scene in order to try out a composition.

Symbol: An object that stands for something other than itself, often an idea.

Tempera paint: A type of paint that is created from ground pigments mixed with a binder, usually egg yolk.

Temperature: An art term for the relative warmth or coolness of a color. Most warm colors are red, orange, or yellow while most cool colors are blue, green, or purple.

Triptych: A three-panel painting.

Trompe l'oeil: French for "fool the eye"; a style of painting in which objects are rendered so exact as to make them appear real.

Ukiyo-e: Japanese for "pictures of the floating world"; a term for woodcut prints and paintings created by Japanese artists between the seventeenth and nineteenth centuries.

Vanitas: A type of art in which objects portrayed in a work serve as symbolic reminders of life and death.

Viewfinder: A tool used by artists to focus in on a particular part of a scene when creating a composition.

Vignette: Small stories included in one larger work of art

Workshop: An artist's studio in which apprentices, journeymen, and others work under a master artist.

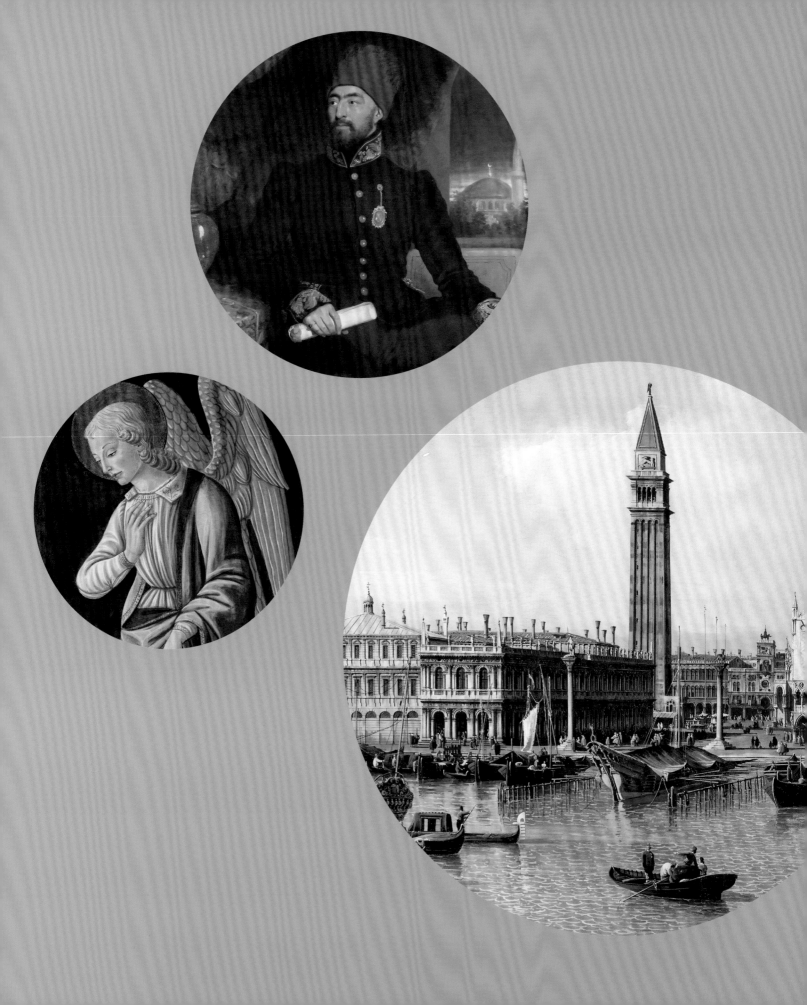

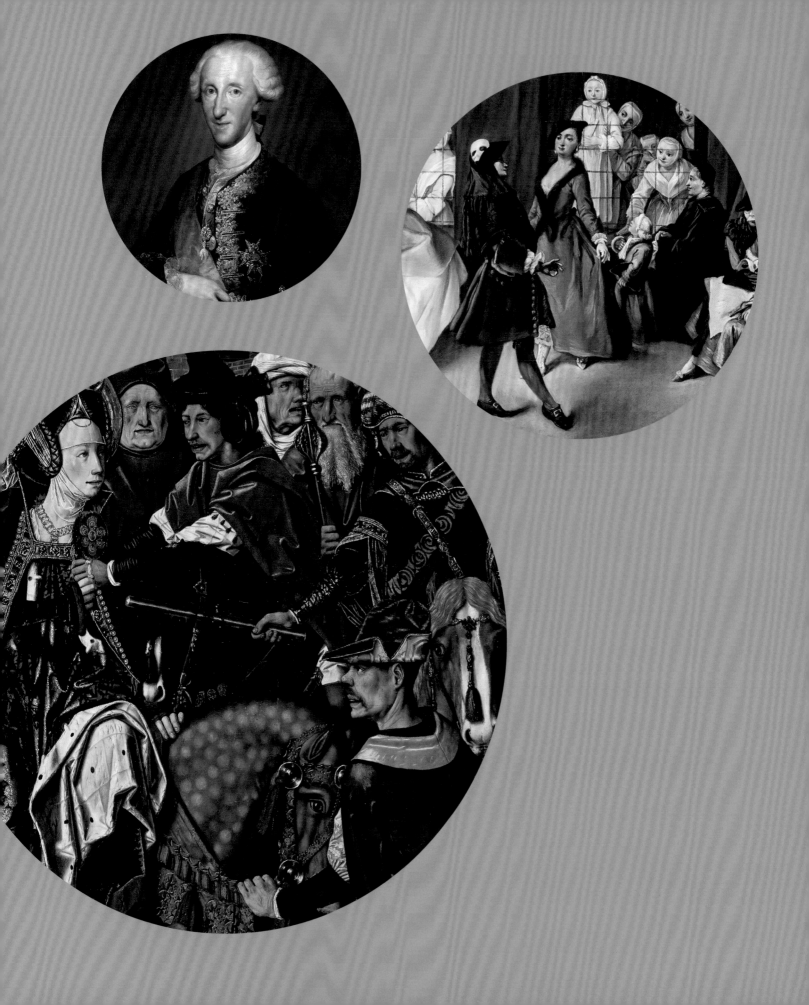

Acknowledgments

Myths, Angels, and Masquerades: Exploring European Art would not have been possible without Sandra Benito, Deputy Director for Education and Public Engagement, who provided the leadership and direction that was instrumental in the realization of this book. Her visionary approach to education has made this project and many other creative endeavors for the Museum a success.

The Curatorial Department staff are greatly appreciated for their ongoing commitment to collaboration with the Education and Public Engagement Department.

Dr. Michael Brown, Associate Curator of European Art, shared his knowledge and expertise as this book was reaching its final stages, and Cory Woodall, Curatorial Assistant, helped greatly by compiling many of the images in this book.

Patrick Coleman, with his meticulous work, served as editor of the publication and provided project support to the writers in innumerable ways. Thank you for tirelessly reading copious drafts of the manuscript.

The beautiful design and printing is thanks to Marquand Books, especially under the creative vision of Ryan Polich and Leah Finger, whose combined expertise helped to frame the vision for this book from its inception through production.

Jose Orara dedicated his skill and creative expertise in creating delightful illustrations that you see on each page. In forming an initial concept for the book, we are grateful to Nury Lee, former Graphic Designer for The San Diego Museum of Art, for her time and talent.

This book was published in conjunction with the catalogue of Italian, Spanish, and French paintings by Dr. John Marciari, whom we thank for providing his research materials and initial feedback. The Museum docents, a dedicated team that contributes to the Museum's research, tours, and programs, also shared information that was integrated into the content that you find here.

Lastly, Roxana Velásquez, The Maruja Baldwin Executive Director, as well as Katy McDonald, former Deputy Director of External Affairs, are due recognition for helping turn an idea into a reality. It would not have been possible to see this project through without the continual collaboration and team efforts of this institution's remarkable staff.

Amy Gray and Lucy Holland

About the Authors

Amy Briere Gray, M.Ed., joined the Education Department of The San Diego Museum of Art in 2008. She is responsible for teen programming, youth art exhibitions, educator programs, family programs, and the Museum Art School, as well as any other teacher or student-related programming that she has developed from year to year. Amy received a B.F.A. in Art History and Studio Art from Syracuse University in Syracuse, NY, and a Master's degree in Visual Arts Education from Lesley University in Cambridge, MA. She is a California-credentialed teacher with over fifteen years of experience working with students and families in art-related venues. In addition to her teaching experiences, Amy has served as an administrator in youth programs and a curriculum advisor to teachers. Through her work at the Museum, Amy contributes to the creation of lesson plan booklets for educators as well as activity guides designed for families to use when visiting the Museum.

Lucy Eron Holland, M.A., has been creating gallery activity guides and other educational materials for The San Diego Museum of Art since 2009. She also teaches art history and fine arts for school programs and community outreach at the Museum. In addition, Lucy is currently a lecturer for San Diego State University, where she teaches Introduction to Art History. She received a master's degree in Art History from San Diego State University and a bachelor's degree in Art History and Studio Art from the University of Virginia. Lucy was previously a graphic designer and adjunct faculty for a community college in Arizona. She has studied art in Florence, Paris, and Madrid, where she interned for the Prado Museum in 2008. As a practicing artist, Lucy paints landscapes in oils and creates hand-painted silk scarves.

Funding was provided by the Donald C. and Elizabeth M. Dickinson Foundation and Rebecca Dickinson Welch in honor of Alek Crissy Dickinson and Connor Michael Dickinson. Additional support was provided by the County of San Diego Community Enhancement Program, the City of San Diego Commission for Arts and Culture, and the members of The San Diego Museum of Art.

Library of Congress Control Number: 2015933943
ISBN 978-0-692-39101-3

Published by The San Diego Museum of Art
www.sdmart.org

Produced by Marquand Books, Inc., Seattle
www.marquand.com

Photography for the Museum by Larny Mack and James Gielow, except where otherwise noted.

Edited by Patrick Coleman
Designed by Ryan Polich
Typeset in Archer by Kestrel Rundle
Proofread by Barbara Bowen
Color management by iocolor, Seattle
Printed and bound in China by C&C Offset Printing Co.

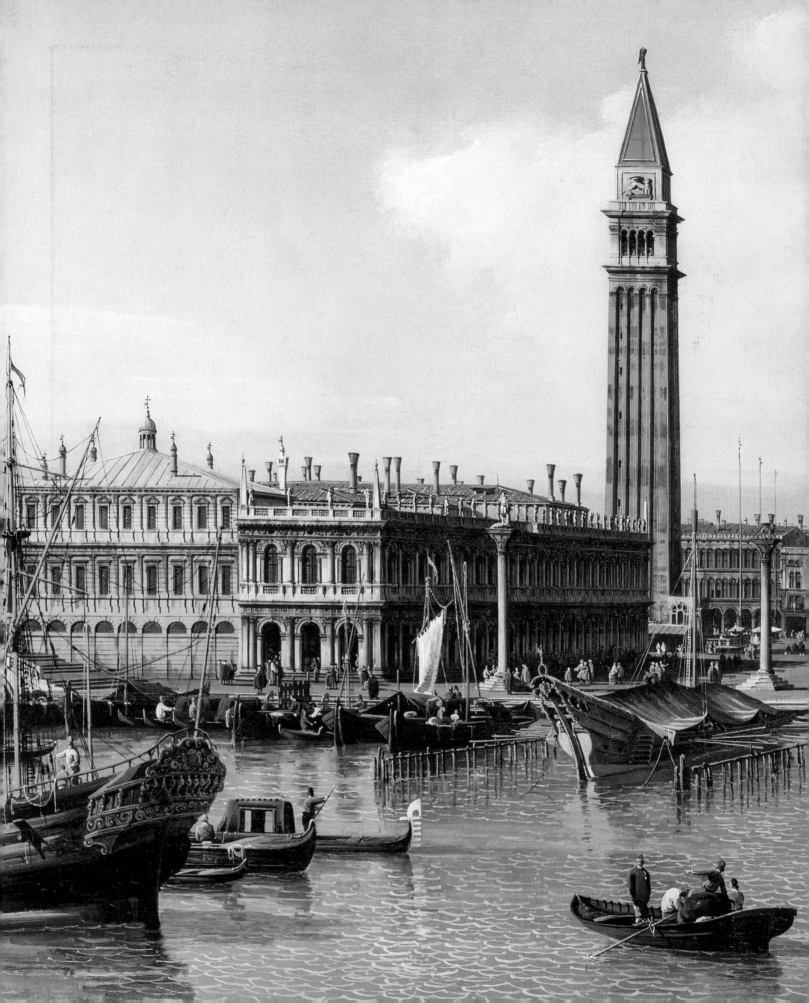